Swarm Tree

Swarm Tree

Of Honeybees,
Honeymoons and the
Tree of Life

Doug Elliott

natural

HISTORY
PRESS

Published by The Natural History Press
A Division of The History Press
Charleston, SC 29403
www.historypress.net

Copyright © 2009 by Doug Elliott
All rights reserved

Illustrated by Doug Elliott, cover photography by Todd Elliott, cover graphics by Billy Bostic of Associated Printing and cover design by Marshall Hudson

First published 2009

Manufactured in the United States

ISBN 978.1.59629.675.6

Library of Congress CIP data applied for.

Contents

ACKNOWLEDGEMENTS 7

CROSSING BOUNDARIES 9

Of Lurking Gators, Leaping Sunfish, Turkey Egg
Omelets and Georgia Cops

CHAPTER 1 21

Swarm Tree: The Day the Bees Fell on My Head

CHAPTER 2 29

My Brief Career as a Migratory Beekeeper: On the
Road with Half a Million Nectar-Sucking Virgins

CHAPTER 3 39

Soul Food in a Southern Swamp: Of Bumming Fish and
Crossing Boundaries

CHAPTER 4 47

Honeybees in a Corporate World: Of Honeybees,
Yippee Protesters and the Miliary Industrial Complex

CHAPTER 5 55

Footprints in the Snow: On the Trail of the Creator

CHAPTER 6 67

Tickled by Trout: Of Good Ol' Boys, Fish Grabbing
and the Handwriting of God

Contents

CHAPTER 7 79

Republicans in the Ramp Patch: Of Possums, Politics
and Smelly Wild Onions

CHAPTER 8 87

The Hunt: Bambi Is Alive and Well

CHAPTER 9 99

Another Roadside Attraction: The Passionate Quest of
the Butterfly Hitchhikers

CHAPTER 10 111

Keep On the Grass: Of Lawns, Weeds and Wheat
Fields

CHAPTER 11 127

Way Down Yonder: Epiphany in the Pawpaw Patch

CHAPTER 12 131

The Scarab and the Sacred Sphere: Of Dung Beetles
and the Source of Life

CHAPTER 13 139

Of Ginseng, Golden Apples and the Rainbow Fish:
Ancient Tales and Mountain Treasures

NOTES 157
BIBLIOGRAPHY 159

Acknowledgements

I 'd like to express many thanks to the multifaceted individuals who have offered me all kinds of support for this project, including editing, critiques, suggestions, hospitality, friendship, companionship and love: Joyce Munro, Alan Muskat, Robert Johnson, Ray and Rosa Hicks, Chris Budke, Bruce Randolph, Robert Hunsucker, Fred Bower, Alden Griffis, Clyde Hollifield, Theron and Doris Edwards, Lee Edwards, Billy Jonas, Dale Boetcher, Becca Munro and especially Yanna and Todd.

Crossing Boundaries

*Of Lurking Gators, Leaping Sunfish, Turkey Egg
Omelets and Georgia Cops*

"STOP RIGHT THERE!"

The piercing command froze me in my tracks. I was
pushing our canoe into a creek at the edge of a south Georgia
salt marsh. Yanna and I looked around and were astounded
to see a police car pulled over on the shoulder.

This book is about crossing boundaries—journeying into new
realms, gaining new perspectives. Sometimes a boundary is defined
by something as tangible as a barbed wire–topped chain-link
fence, as political as a mere dotted line on a map, as legalistic as an
interpretation of the law or as mutable as the shoreline of a tidal
creek, and sometimes it is as unfathomable as the tender edges of
a lover's heart.

Come join me on this adventure. It's sort of a down-to-earth
spiritual journey. We'll be following tracks, messing with bees,
chasing butterflies, stalking deer, catching fish and picking up
pawpaws—and hitchhikers. We'll be learning the lore and natural
history of the plants and animals that we encounter, but we'll also
be probing creation itself, asking the deeper questions and learning
the stories that connect us all. Speaking of stories and crossing
boundaries, let's get back to that roadside/swampside confrontation
with the south Georgia gendarmes.

Our canoe was nestled in the shallow tip of a tidal estuary
that extended under an eight-foot chain-link fence into the
mowed highway right-of-way. The water was less than a

foot deep, and it was two or three feet wide—just the width of our canoe. Because the creek was in a low spot in the terrain, the bottom of the fence was still a couple of feet above the surface of the water—just the height of a canoe. It would be easy for us to duck under the fence. This was a perfect entry point to explore the extensive salt marshes and Cumberland Island, a barrier island, off the coast. We were looking forward to camping out, foraging for wild foods and enjoying the sunshine and salt air.

We learned that the only public transportation to this pristine island was through a ferry service from the town of Saint Marys. But canoes were not allowed on the ferry. We obtained a county map and asked a sporting goods store owner if he knew any other places from which we could canoe out to the island. He pointed out a public boat landing on one of the many serpentine tidal rivers that wind through the salt marshes. We could put in there, he said, but it would be more than fifteen miles to the island. Some of the water was open and could possibly be choppy and difficult canoeing, especially if there was a strong headwind or tide. The map showed that there was nothing but extensive salt marshes on either side of the river—not the sort of place you would want to pitch a tent.

When I asked about another road that terminated at a creek much nearer the island, he said that there was a large chemical plant at the end of that road. There was no boat ramp or public access to the water there, he assured us. We thanked him and left. In spite of what he said, I couldn't help but notice that on the map there was a hairline that might just indicate a branch of a creek. It looked like it might reach the road. Such a stream would mean little to most boaters but could mean everything to canoeists. We had to check it out.

We drove to the end of the road and, sure enough, it ended at the gates of an immense factory. There was a gatehouse and that chain-link fence around the property. The factory was set way off in the distance like a billowing science fiction city. There was a parking lot for semi trucks and trailers

outside the gate on the left. As we approached the gate, we slowed down to scan the right shoulder of the road, looking for the stream that our map had hinted at. Could it be that it just might meet the road and be our access to the sea?

Not thirty yards from the gatehouse our prayers were answered. There it was: the tiny tip of a tidal estuary. The water extended under the fence into the mowed highway right-of-way for about fifteen feet—exactly the length of our canoe. It looked like it was not fifty yards until it flowed into the open water of the main creek. Just what we had hoped for! This would work fine if we could only get permission to leave our vehicle somewhere in the area.

In the gatehouse there was a lone man working. His job was to monitor the flow of goods and traffic, as well as to stop unauthorized traffic from entering the factory grounds. We told him what we wanted to do and asked if we could leave our pickup truck there outside the gates. He looked the situation over thoughtfully and said, "I don't see why not," and he showed us where we could park our truck. We thanked him and proceeded to unload our canoe and assemble our gear. We knew we had to work fast. The tide was one concern. It would be going out soon and might just leave our boat high and dry. Our permission was our other reason for urgency. As easily granted as it was, we knew that it was coming from near the bottom of a massive corporate hierarchy and that this permission could be as ephemeral as a mayfly, dissipating even faster than the rapidly receding tidal waters. We loaded our packs, sleeping gear, tent, camera, lenses, film, field guides, binoculars and cooking gear—a light wok and a stainless pot. We quickly threw in what food we had brought—rice, a few sandwiches, some citrus and granola. Even at our frenetic pace, it still was an hour before we finally had the canoe loaded and we were ready to go. Yanna got into the bow of the canoe, and we were finally ready to shove off.

That's when we were stopped in our tracks by the voice from above. The officer addressing us was a small woman with

wavy blonde hair. She was in full uniform. Pure unbridled authority oozed from her every pore as she suspiciously glared down at us from the shoulder of the road. This woman was not to be messed with. She was accompanied by a heavyset, middle-aged man. He wore regular, casual clothes and a cap with a bill that had "Camden County Sheriff's Department" emblazoned on the front. We wondered if he was a fellow officer and if this was the official men's uniform. "Now just where do y'all think you're goin'?" she demanded.

"We just wanted to paddle out into the swamps and take pictures of birds and wildlife and stuff, and go camping on Cumberland Island," I drawled. "We're not tryin' to cause any trouble, ma'am. This is a public highway right-of-way here, isn't it, and that water is tidewater, isn't it? We didn't think we were doing anything illegal." I was trying to impart a submissive tone to my words, while tactfully informing her that I knew my rights. (I thought I did, anyway.)

She considered this a moment and then warned us that even though the canal might be tidewater (which is public domain), the land on either side of the canal was private,

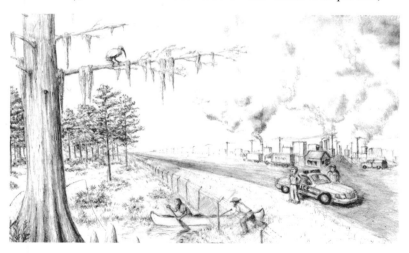

The officer glared down at us from the road shoulder. "Now just where do y'all think you're goin'?"

and if we were to be caught trespassing or camping on any of that private land she would have to give us a "citation." We thanked her for her timely warning and her helpfulness. They got back into the car, turned around and roared away. We breathed an elated sigh of relief, scrambled back into the canoe and shoved off. We pulled ourselves under the fence and followed the creek as it wound through the wax myrtle bushes and gradually got deeper. Before long, we were merrily paddling down the narrow channel, giddily teasing and admonishing one another not to touch either bank or we might get a citation.

We paddled for an hour or two, and soon we were drifting down a wider river as the sun set. We found a small, elevated piece of land at the edge of the marsh and spent the night. The next morning we followed the creek to where it joined the Intracoastal Waterway. We paddled across the waterway, and there we were at Cumberland Island. The tide was low as we pulled up to a deserted section of shoreline, and as we beached the canoe I could see oysters everywhere. Fresh oysters! This was one of the more pristine areas of the eastern seaboard, and I was ready to start chowing down on those mollusks. Knowing that Yanna had years of vegetarianism and somewhat of a distaste for seafood, I knew that downing a raw, live, slimy oyster would be a huge cognitive shift. But I had a little trick in mind. We started a small fire on the bare sand, where it would make no impact on the vegetation, and I started carefully placing the oysters in the coals. Well, it wasn't long after those fresh oysters started sizzling in their juices in the fragrant smoke of the campfire that she was ready to let that vegetarianism slide. We had a great meal, and that was the beginning of her "downfall" from vegetarianism and the beginning of her "climb" up the food chain. We were about finished eating when we saw two men in a boat speeding along. On the side of the boat was written "Georgia Game and Fisheries." When they saw us, they turned and headed straight for us. I thought, "Oh no, we are busted already! I wonder what we are doing wrong."

When they got within hailing distance, they cut the engine and said, "You better be careful with that fire. You are on national park land, and they have rules about fires in undesignated areas. If they catch you, you'll get a citation."

"I thought you are allowed to have a fire on the beach," I replied.

"You are," he said, "but you need to be down lower, nearer the waterline. You're too close to the woods." (It was very windy so I had built the fire close to the shore in the lee of a fallen tree.)

We thanked them and quickly doused our fire. Wow, just a friendly warning! We weren't in their jurisdiction. We were on federal lands and these guys were state officials. We couldn't see it, but there was a boundary line between us. Whew!

Now that our bellies were full and the fire was out, we were ready to explore the island, so we hauled the canoe up onshore and hid it in a palmetto thicket. We loaded our packs and headed into the island's interior. The place was a fantasy world of maritime forest with sprawling live oaks, tall pines and shrubby palmettos. We headed east until we came to the beach on the ocean side. Although it is a national park with designated camping areas, in those days camping on the beach was permitted because maritime shoreline was considered public domain, and the beach with its shifting sands is such a transitory, changing environment that camping there leaves no lasting impact. We set up our tent where we'd have a view of the ocean. That night we were lulled to sleep by the sound of gentle ocean breakers lapping the shore.

The next morning we were up before dawn, hiking the beach and watching the sunrise. Later in the morning, I was feeling the need for a nap—about the time Yanna was feeling the need for a swim. We had seen a large shark in the breakers the evening before. Talk about defining boundaries! She thought she would try to find some shark-free fresh water. We had seen on the map that there was a lake about a mile away.

The trail was clearly marked so she decided to head for the lake while I napped. We agreed that we'd either meet at the lake, on the trail or back here where we started. An hour or so later, I was just starting to awaken when back she came.

"How was your swim?" I asked.

"Well, I have a couple of stories and something to show you," she said with a smile, and she led me down the road.

The trail that Yanna had taken led along a dirt road. She walked along quietly, enjoying the solitude, the morning light dappling the palmettos and the gentle sighs of the wind in the pines. In the distance, she heard some human sounds—distant laughing and shouting. Then she noticed that the sounds were getting louder—and closer. It was a vehicle approaching. It sounded like a truckload of people in party mode. (Part of the island is privately owned, and the landowners and their guests are allowed to use cars in certain areas.) It was a rowdy fiesta on four wheels, and it was coming her way. To avoid any confrontation, Yanna quickly dove into a palmetto thicket and crouched, hiding while they went by. After the revelers passed, she was astounded to see right there on the ground in front of her a nest with a dozen very large, faintly speckled eggs. A turkey nest? she wondered. She marked the place so we could find it later and continued on her way to the swimming hole. She finally came over a sandy mound and was thrilled to see a beautiful lake lined with water lilies, a sandy beach and even some open water that looked perfect for swimming. There was no one around. She could skinny dip! She ran down to the lake and was about to strip down and jump in when she was startled by the huge splash of a large, surprised alligator beating her into the water. (Last one in is gator bait!) The alligator came to the surface about fifteen feet from shore. It turned and lay there in the water, quietly staring at her. It was hard to feel comfortable jumping in for a swim under these circumstances.

She took me back to the nest. One egg was cracked, but the other eggs looked to be in perfect condition. The island,

like most coastal barrier islands, is an overgrown sand dune, so there are many large patches of bare sand even in shrubby areas like this. It is a tracker's paradise, with networks of animal tracks and trails all over—coons, 'possums, armadillos, bobcats, turkeys, doves and songbirds—even snakes and lizards leave clear signs of their passing. The sand records a clear imprint of everything that happened there since the last rain. It was surprising to us that this nest had no tracks nearby, and it had been more than a week since any rain had fallen. If the mother turkey had been brooding her nest, her tracks would have been obvious. We supposed that she had been dragged off or ambushed while away from her nest. There was one set of raccoon tracks that passed within three feet of the nest. The coon had apparently been completely unaware of it. It was amazing that the nest had so little odor that a coon, with its sensitive nose, had passed that close without knowing that it was there.

We wondered about the condition of the eggs. Eggs will keep several weeks without refrigeration so I popped a small hole in the end of one and looked inside. Inside we could see clear egg white, with a bright yellow yolk and no bad smell whatsoever. These eggs were in fine shape. I could almost taste them fried over a campfire. Would this be legal? In national parks it is against the law to disturb animals or destroy plants. It is legal to pick fruit if you consume it in the park. These eggs, abandoned as they were, were not exactly animals being disturbed by us. And, in some ways, they were like fruit, we rationalized. Turkey fruit—gobble-berries! Here again we were on another boundary—where do we draw the line? We decided to think about it over an omelet. So we gathered a few cattail shoots, some wild garlic and a few leaves of sea rocket, and we cooked up an extraordinary gobble-berry omelet there by the lake.

That night, there was a vibrant chorus of frog calls and other mysterious night sounds coming from the lake. The air was warm and mellow, and there was no moon. I was with my favorite woman in the entire world. Finding a small

aluminum johnboat there and having the place to ourselves, we borrowed the boat for a romantic nighttime cruise around the lake. Yanna sat in front, while I stood at the stern like a gondolier and poled the boat along in the damp, sensual darkness near the edge of the lake. The riotous, throbbing cacophony of the frog chorus lent a dreamy otherworldly quality as we floated along suspended in the darkness. Suddenly I heard a splash, a startled shriek from Yanna and a great commotion in the bow of the boat. We grabbed for our flashlights, flipped them on and were astounded to see a fish in the boat—it had jumped out of the water, slammed into Yanna's bare leg and was now frantically flopping about the bottom of the boat. It was a sunfish—a bluegill, or "bream," as it is called in the South.

That was a wonderful turn of events. We were running low on provisions. A grilled fish would make a great supplement to our food supply. We settled down and continued poling around the lake in the darkness. We hadn't gone far when I heard another splash and another startled squawk from Yanna. She had been struck by another flying bluegill, and this one, too, was now flopping on the bottom of the boat. Great, now we had two fish. I realized that we had stumbled on a good fishing technique, and at that moment I might have crossed the line (another one of those boundaries) and become an outlaw. I'm sure it's not against the law for an unlicensed person to have a fish accidentally jump into his boat, but I had crossed over. Now I was fishing! I didn't have a hook, line, rod or net, but I was fishing. I was now intentionally trying to induce fish to jump into the boat! I was fishing without a license. I had crossed the line once again, and once again, I had become an outlaw.

I figured that these fish had been nesting in shallow water near the edge of the lake, and when this large, slow-moving, alligator-like form cruised by, the fish leapt into the air in a mad dash for the safety of deeper water. If it had been a gator, they could have leapt right over its back. Instead, the ones that leapt high enough ended up in the

boat—or in Yanna's lap. By the time the evening cruise was over, we had four fish. The next morning, we gathered a few more eggs from the nest, cooked our fish and made another turkey egg omelet.

We had a marvelous time on the island, and after a few days we headed back. It was a warm day, and there were sea breezes blowing in from the east. We were able to attach the tent fly to one of the paddles and sail most of the way back up the creek to where we had originally started. By mid-afternoon, we were pulling the canoe back under the chain-link fence.

As we started unloading the canoe, we had no idea of the welcome we were about to get. Several truckers approached us with big grins. "Looks like y'all made it back!"

"Yeah we did pretty good out there," I drawled in reply.

"You're the ones that told them cops off, aren't you?"

"Well…I don't know what I told 'em but…yeah, I guess that was us."

"Yeah, we been laughing about that. Them cops just took off outta here after they talked to you, and we ain't seen 'em since. I don't know what you said, but I'll tell you, things are a lot more peaceful around here without them cops nosing around all the time."

Along with gators and flying sunfish, I'll be introducing you to a number of other interesting critters and plants, as well as some extraordinary human characters. Along with truckers and Georgia cops, you'll be meeting old Appalachian mountain folk; young, rowdy good ol' boys; hitchhikers with butterfly nets; a renegade PhD; an ancient African American wise woman; and my own sweet wife and son. These folks have special relationships with nature and share unique perspectives that can help us stretch our own boundaries and more fully realize our multifaceted connections to this wondrous web of life of which we are a part.

At the end of many of the following chapters I have included natural history notes with information about some of the plants

and animals and their ecological and cultural relationships. These notes bring the background into focus, flesh out the setting and give a broader and deeper context to the stories being told.

So I welcome you on this adventure. We'll be diving deeply into the richness of the natural world and coming back to the surface—we'll be climbing high into the tree of life, exploring some of its branches and returning to earth—with amazing stories, hilarious insights and deep spiritual truths, truths that illuminate the confluence of nature, humanity and spirit.

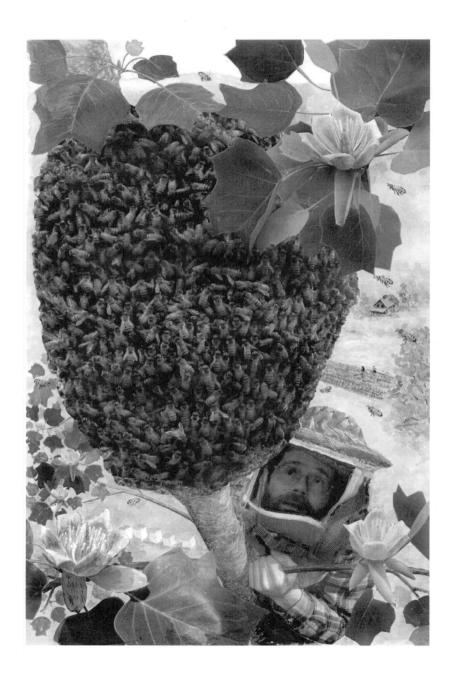

Swarm Tree

The Day the Bees Fell on My Head

I was fifty feet up a tree. It was in the spring of my fiftieth year when fifty thousand bees fell on my head. Fifty thousand bees weigh more than you might think—maybe four or five pounds. The mass landed heavily, with a buzzing thud, and pushed my hat down to my ears. Within a few seconds I was virtually covered with bees. They oozed down over my shoulders, arms and trunk like a mass of living, breathing, buzzing pudding. The bees that missed me began flying back, frantically hovering and trying to rejoin their hive mates that were crawling all over me.

I was so glad that I had worn my bee veil. I had my long-sleeved beekeeper's gloves, too, but the gloves dangled uselessly from my back pocket. I wanted to have a good grip on the branches while climbing the tree so I hadn't worn them. My long-sleeved shirt offered some protection, but those bees tickled as they crawled all over my unprotected wrists, exploring my open sleeves and the white knuckles of my bare hands as I grasped those treetop branches for dear life.

For some reason I got to thinking about a honeybee's stinger. It is such an amazing organ. A bee's stinger is much more than a simple hypodermic needle. It has three moving parts that work together. The top of the stinger is a needle-sharp stylus. Underneath the stylus are two barbed lancets. Together these three parts form the three-sided venom canal. At the base of the stinger is the muscular venom gland.

When a bee stings you, she jabs that needle-sharp stylus in you, and those two barbed lancets start working back and forth. The

barbs catch in your flesh, and they pull the stinger deeper and deeper. Meanwhile the venom gland pumps the venom down the canal, and that's when you start to feel "a pain so characteristic that one knows not wherewith to compare it; a kind of destroying dryness, a flame of the desert rushing over the wounded limb as though these daughters of the sun had distilled a dazzling poison from their father's angry rays."[1]

When the bee tries to fly away after stinging, she can't escape until her rear end tears off because the stinger is anchored so securely. Even though she has flown away, the stinger remains, and the venom gland continues injecting more and more venom. (So if you do get stung, you should, as quickly as possible, try to scrape, rather than pinch, the stinger to remove it.)

The unfortunate bee flies off, mortally wounded, and she dies. If you are allergic to bee stings, you might die, too. Even if you are not allergic to bees, getting stung by a few hundred of them can still be quite serious—especially if you are fifty feet up in a tree when you get these stings. So I decided right then and there that this was not a good time or place for panic. I took a deep breath.

I couldn't help but notice that these bees were not stinging me. Bees don't really "want" to sting. It is such an investment to sting; if they sting, they die. However, in order to protect their hive, their home, their babies and their queen, they will sting and give their lives if necessary.

This was a classic bee swarm, not a virulent hoard of stinging marauders. These bees were homeless and vulnerable. They had outgrown their living quarters and left their home for the next generation. Before they left their hive, they gorged themselves on honey. Their bellies were full, and now they were hanging out and feeling mellow (at least they were before they fell on my head). Without a home or babies to protect, they had little reason to sting.

"Homeless?" you may ask. Why were these bees homeless? From up in that tree I could see all my neatly painted beehives lined up down below—more than a dozen. I had assembled and painted them. I hauled in cinder blocks and wheel rims for hive stands

to keep them up off the damp ground. I put frames with comb foundation in there for them to use in making their honeycomb. I gave them supers in which to store their honey. I fed them when they were hungry and gave them medicine when they were sick. Why were these bees hanging out up here in this tree being homeless?

This is the way of honeybees. This swarm was made up of all the active field bees and the queen from one of those hives down below. They had been working hard since late February when the first maples began to bloom, and they had built up their colony rapidly. There were many thousands of workers. They had filled their hive with comb, brood and a great store of honey. It was getting crowded, so now it was time to hand the hive over to the next generation. The queen and all the active field bees were flying off together to start over in a new location.

It was a bright, sunny May morning. Yanna had been hoeing the corn patch. I had been making baskets in front of the shed by the edge of the garden. The tulip poplar trees were in full bloom. The air was filled with bird songs and the tranquil hum of the honeybees. Was that really a *tranquil* hum?

"You better check your bees," Yanna called out. "It sounds like they're at it again."

Sure enough, I could hear frantic buzzing from a hundred feet away, and it was increasing in intensity. By the time I ran over to the bee yard, a mass of bees was frantically pouring out of one of the hives. The air was filled with a cloud of bees. I looked up to see thousands of dark specks streaking in every direction across the

pale blue sky. I felt like I was the nucleus of an atom watching my electrons zooming around me.

In a typical swarm, the bees fly out of the hive and land en masse (usually within twenty yards) on a bush, in a tree or on a fence post, hanging onto one another in a huge, dangling gob. No one knows how long they will stay at this initial reconnoitering post. It could be a few minutes or possibly a few days. From here scout bees fly off to explore the countryside, looking for a new hive site.

If you are an alert beekeeper and you have an extra vacant hive ready, you can often catch the swarm. You take that empty hive body, put some frames with comb foundation or brood in it, remove the cover and lay it under the swarm, and then you lean that bush or branch with the bees right over the hive and give it a good shake. Most of the bees will fall straight down into the hive. If the conditions are right (especially if there are a few frames of honeycomb or young brood in there), it's as if they say, "Oh yes, this is just the kind of place we're looking for." And like a parade, they all just march in and make this hive their home. You just ease the cover on and wait until dark, when you can put the hive where you want it. Now you have a new hive of bees. Catching swarms is a simple way (well, sometimes) to increase your number of hives and reclaim your runaway bees as well.

That's what I was doing up in the tree. This was a huge swarm, as big as a bushel basket, right near the top of the tree. It had come out of one of my best hives. These were all the working field bees and the queen from my strongest hive. With most of the workforce gone, it meant that I probably would not get much honey that year from the bees that remained in the hive. I wanted that swarm badly. I put up a twenty-five-foot extension ladder that reached the first branches, and from there I climbed from branch to branch up the tree.

I had a small pruning saw and a long rope with me. The bees were massed in the fork of a branch about a foot out from the trunk. The branch was barely two inches in diameter. My plan was to tie a rope onto that branch, carefully saw it off and slowly lower the branch with the swarm fifty feet down to the hive that I had open and ready underneath.

Swarm Tree

It really might have worked—except for that one dead branch right under the big swarm. I thought I might test it to see how strong it was. I held on securely to other branches and put one foot on it to see if it would hold me. Sure enough, as soon as I had most of my weight on it, the branch snapped. I was holding on securely to those other branches, but when that dead branch snapped, the whole tree shook and that's when the bees fell on my head.

Now I had all these bees on my head, crawling all over my body and flying all around me. Their buzzing got more and more intense until it was a whining roar. I was surrounded by a swirling mass of thousands of bees. Their sound was all I could hear—and then they came together in the air right in front of me, congealed into a tight swarm and took off out of the tree, heading over the garden and toward the woods. That sure took a weight off my shoulders.

I watched them sail across the garden and over the shop, the woodshed and the pond. They headed up the mountain, flying up above the trees, and the last I saw of that swarm, they looked like a floating, ever-diminishing smudge against the clear blue sky, until they finally disappeared over that mountain. They left me speechless and blinking, stunned but unstung, still clinging to the branches high in the crown of this swaying tulip poplar tree. Hundreds of orange, yellow and green blossoms surrounded me. Large, tender, sun-dappled leaves shimmied in the gentle breezes.

From my perch, I could look down over the garden, the bee yard, the house, the sheds and the rest of our little homestead. What a great place this was for an overview, a place to get a different perspective on things. Here I was, fifty feet off the ground. I was a half century old, on a threshold of sorts—a boundary between heaven and earth, somewhat desperately clinging to the branches of this tree of life. This was a good place to contemplate my own mortality. No, it would not be good to fall from here. It was also a fine setting in which to contemplate the miracle of nature, as well as the complexity and absurdity of human endeavor—like risking my life for a swarm of stinging insects?!

Poplar Appeal

A large tulip poplar lit up with hundreds of large cuplike blooms is a magnificent sight indeed. The flowering of these trees is very important to beekeepers. It is one of the most dependable sources of nectar in the Southeast. The yield of nectar per bloom is possibly the highest of any plant on the continent and has been calculated at an average of 1.64 grams per flower (that's about one third of a teaspoon). During a favorable season, the nectar is secreted so abundantly that honeybees and other insects cannot carry it away as fast as it appears. Sometimes you can stand under a blooming tulip tree in a light breeze and feel the nectar dripping down like a gentle, sticky rain. (People who park their shiny cars under tulip trees often complain about this.) Because the bloom comes early in the season, many honeybee colonies are not strong enough to fully utilize the abundance. For strong hives, however, harvests of one hundred pounds of honey per hive have been recorded during just the three-week tulip poplar bloom. The honey is dark in color and is sometimes called "black poplar honey." When held up to the light, however, it can be seen that it is actually a deep amber-red in color. Though it is not as light as locust honey or as sought after as sourwood honey, it has a rich, full-bodied flavor that can be used to sweeten fruit salads, yogurt, tea and other beverages. It's great on pancakes, waffles, cereal, biscuits, corn bread and other baked goods. Rarely a day goes by that I don't eat some.

Swarm Tree

If you want the ultimate tulip poplar nectar–tasting experience, you can sip it straight from the flower like the bees do. To do this, you need to find a freshly opened blossom within reach. Pick or lower the blossom carefully without jostling it. Then lick the droplets on the inside of the petals and taste that ambrosia! Sometimes the nectar collects in a puddle on one of the lower sepals. If the air has been warm and dry, the nectar will be thick, like syrup. After one taste, you will know that you have consumed the nectar of the gods!

When I tell northerners that I built my house almost entirely of poplar, including the framing, rafters, interior paneling and exterior siding, they seem confused. When I go on to say that there are a lot of old log cabins in the Appalachian Mountains built from large poplar logs, they look at me like I'm crazy.

I finally learned that to a northerner, the word "poplar" refers to aspens and other related trees, whose wood is light, soft and virtually useless for house construction. After a bit more discussion, we finally get our terminology straightened out, and I get the response, "Oh, you mean tulip tree."

Yes, this magnificent tree has many names and even more uses. It is not a true poplar but was so named because its leaves are attached to its branches by long petioles, or leaf-stems, that allow the leaves to move in the breeze in a manner not unlike that of a quaking aspen.

Tulip poplar is actually in the magnolia family. Its scientific name, *Liriodendron tulipifera*, translates as something like "tulip bearing lily tree." This is a great name for the tree because its flowers look like a combination of a tulip and a lily. They are a light greenish yellow, and each of the six petals has a blaze of orange at its base. As Maurice Thomas wrote:

> *Out of a giant tulip tree*
> *A great gay blossom falls on me;*
> *Old gold and fire its petals are,*
> *It flashes like a falling star.*

For more on tulip poplars, see *Wildwoods Wisdom*, and for instructions on how to make poplar bark baskets, see *Woodslore*.

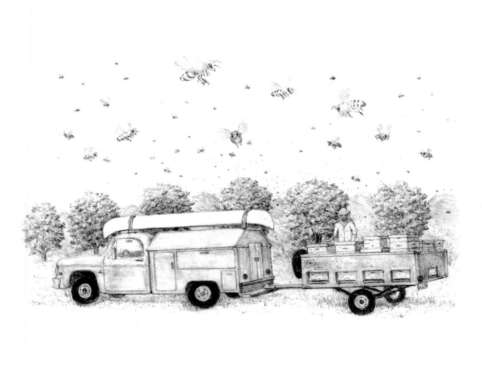

My Brief Career as a Migratory Beekeeper

On the Road with Half a Million Nectar-Sucking Virgins

She's as sweet as tupelo honey, she's an angel in the first degree.
She's as sweet as tupelo honey, like honey dripping from the tree.
—Van Morrison, from the song "Tupelo Honey"

Speaking of complex and absurd human endeavor, there was the time I took my bees south to Florida for the winter. The idea had started several years before, back when I used to travel south in February or March to greet spring in the subtropical southern lowlands and slowly accompany the season back north, arriving in the high Carolina mountains in time for the ramps (wild leeks), wild spring greens and the first woodland wildflowers.

After a good dose of blizzards and icy winter weather, there was something alluring about sliding my canoe into a warm, wet, subtropical southern wilderness waterway and feeling it all come to life—the warm sun, the fresh soft verdancy of unfurling leaves, the heady fragrance of bursting blossoms, the urgent hormonal roar of thousands of frogs calling in the murky darkness and the exuberant chorus of songbird courtship at dawn. This vernal intensity was like a delicious drug to me (overgrown, romantic adolescent that I was). I was hooked on immersing myself in the energy of spring, as well as prolonging and savoring the springtime of my own life.

On one of these vernal peregrinations I met two migratory beekeepers. They were camped in the Choctawhatchee River swamps in the Florida panhandle in late April. Each of them had hundreds of hives in what are called "locations," down dirt roads in piney savannas, oak hammocks and palmetto thickets within

Nyssa ogeche, better known as tupelo or Ogeechee plum, is the source of tupelo honey.

easy bee-foraging distance of the river's edge. Lining the inundated flood plains and sloughs of this and other Florida panhandle rivers are the famous black-water tupelo swamps, home of *Nyssa ogeche*, better known as tupelo or Ogeechee plum. This tree is best known as the source of tupelo honey, which is unequaled for its sumptuously flavored bouquet of sweetness.

These beekeepers would stay in this area for about three weeks while the tupelos were in bloom. They had spent the winter in central Florida in the citrus groves, where their colonies built up strength and the bees brought in a good crop of orange blossom honey. In April, when the citrus bloom had faded, they loaded the hives onto flatbed semi trucks. (They were already on pallets—four hives to the pallet, four hundred or more hives on a truck.)

They strapped the hives down securely, covered them with nets and drove through the night to arrive at their tupelo locations the next morning. After the tupelo flow, they would return home with their bees, one man to Maryland in time for the tulip poplar bloom and the other back down to Florida in time for the flowering of the cabbage palms. (Other beekeepers they knew would then head to the Dakotas for clover or to Maine to pollinate blueberries.)

Wow! What a way to make a living, I mused, following flower blooms to far-flung locations, bringing in pollinators and collecting gallons of sweet honey. Following the bloom, traveling from one nectar flow to another, would surely give one a unique perspective on the world. I could imagine seeing the world as one big nectar flow.

This really is a very sexy business, at least as far as the plants are concerned. Flowers, of course, are the plants' reproductive organs. Bees and other insects are actually sex workers. They are the

flowers' hired help. They are employed to move pollen, the sexual material, from the bulging anthers of the male to the moist, sticky stigmas of the female. The bees are paid for their services with sweet nectar, which is doled out in small amounts on somewhat of a schedule over the entire flowering period. This keeps the bees interested and actively manipulating the flowers' sexual parts until pollination is complete.

Wow, traveling around with thousands of pollinators working for you; the entire workforce is composed of virgin females! This was a heady thought for a lusty young romantic.

Over the next few years, I did acquire a few hives and gained a small amount of confidence in working with them. I caught some swarms and expanded my bee yard until I had six hives. During some seasons the bees produced enough surplus honey for me to sell and start paying for some of the supers (hive boxes) and other bee equipment that I had purchased. I still traveled a great deal, collecting herbs, studying nature and doing art and photography. Occasionally, I thought about migratory beekeeping, but I was nowhere near the hundreds of hives it takes to fill a semi trailer, nor did I have the capital, experience or mindset to commit to that kind of a full-time career.

Then some friends announced that they were moving to Florida and would be living in a house with a large yard, surrounded by

When the bloom faded, they loaded the hives onto flatbed semi trucks and moved to the next location.

hundreds of acres of citrus groves. Yes, it was fine with them if I put some bees there.

Again I found myself on one of those thresholds. Was this an opportunity or a foolish notion, I wondered. Both, I concluded—like so much in life. I already had a stout 1966, three-quarter-ton Dodge pickup truck with a slant-six engine. It was a rugged vehicle. You could fill the truck bed with a ton of rocks and hardly notice a difference in how it drove. This vehicle would easily pull a trailer with bees and honey.

Before long the fantasy became a reality. I acquired a used, homemade, six- by twelve-foot trailer with two-and-a-half-foot sides. It would hold ten hives. I bought four more colonies from a retiring beekeeper that fall. During a cold snap that winter, when the bees were inactive, I cut openings in the sides of the trailer, one for each hive, and moved the hives into place. Each hive faced its own opening, and I secured it to the wall of the trailer so it would not shift in place during the trip. There were four hives on each side, one in the back and one hive facing the front. This left an aisle in the center where I could stand and work the bees. I filled the back of the truck with supers, hive parts, tools and camping gear, and I tied my canoe on top.

I departed one wintry afternoon, heading south. I had the trailer with the bees covered tightly with a tarp. I knew that they would be getting more active as the climate warmed, so I had screens stapled over the openings to contain them. Leaving when I did, I hoped to be doing most of my warm weather driving in the dark, when the bees are reluctant to fly.

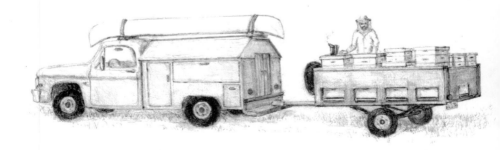

My Brief Career as a Migratory Beekeeper

In the wee hours that next morning, I found my friends' place and pulled the trailer into an out-of-the-way part of the yard. I removed the screens from in front of the hives and unrolled my sleeping bag for some much-needed sleep. By the time I awoke the next morning, the bees were circling all around the area, making orientation flights and checking out their new territory. It seemed like their buzzing had a surprised, enthusiastic quality. My friends were excited about these new neighbors. I stayed around for a couple of days to make sure the bees were settled and that each hive had several empty supers to fill during the upcoming citrus bloom. I wished everyone (the bees and their hosts) well and headed back north.

I had two important stops planned on the way. The first stop was to find a location where I could park my beehives during the tupelo honey flow. I headed to the Okefenokee country in southern Georgia, where I talked with Alden Griffis, who lived on the banks of the Suwannee River at its source, where it flows out of the Okefenokee Swamp. I had canoed the river in that area and knew that it flowed through a river swamp that was full of tupelo trees. I asked Mr. Griffis if he would allow me to park my trailer of bees on his property during the tupelo bloom. He had a few hundred hives there already. He seemed slightly amused at my plan, but he generously said that he didn't see why ten more hives would make much difference to his operation. Yes, I could park my trailer there.

The second stop had to do with an interesting young woman named Yanna. I first met her a year or so before when I was performing at the tenth anniversary of the National Storytelling Festival in Jonesboro, Tennessee. I had been telling groundhog stories (see the second chapter in *Wildwoods Wisdom*) and singing the song "Oh Groundhog," a folk litany praising the usefulness of the various parts of the groundhog with verses like:

> *We'll eat that meat and we'll save the hide*
> *Makes the best shoestrings you ever have tied. Oh Groundhog!*

After singing the song, I mentioned that I just happened to be wearing genuine groundhog hide shoelaces on my shoes, and if

anyone was interested they could come see them after my program. As soon as the set was over, a mysterious and beautiful young woman with long, shiny black hair emerged from the crowd. She came right up and asked to see my shoes. She took one look at the laces, nodded and then disappeared back into the crowd.

I found out later that she had two reasons for checking out those shoelaces. First of all, she had been listening to storytellers all day, and she had heard all kinds of stories, from fanciful folk and fairy tales to legends, literary stories and tall tales. Then this fellow comes onstage who was telling stories from his life that he claimed were true. She liked what she heard, but were they really true? If this guy really did have groundhog shoelaces, that would give him at least some credibility.

The other reason she wanted to check out these home-tanned shoelaces was that she had a deer hide in a bucket in her backyard. She had acquired the deer hide because she had been talking to her trophy hunter neighbor, and when she found out that he was only interested in the head and he threw away the hide, she started ranting about how wasteful it was.

That deer hunter quietly listened to what she had to say, and when he shot his next deer you can guess what he did with the hide. Yep, there it was one morning—a bloody heap on her doorstep. She didn't know the first thing about how to process a deer hide. So she hit the library and found a number of articles and books, each one with different methods, opinions, formulas and tips about how to proceed. She got the hide fleshed, and then she soaked it in an alkaline solution of wood ashes and water to remove the hair. She wanted to try brain tanning (an aboriginal method of tanning using a slurry of the animal's brain to soften, and wood smoke to condition the hide). However, the brains of this critter were not available. They were at the taxidermist's shop along with the trophy head. One article said that a substitute would be to soak the hide in a bucket of lard and homemade soap for a week or so. She placed the hide in the bucket, but she never did get around to taking it out, and that's where it had been for six months.

I might have never seen Yanna again, but it turned out that we had mutual friends at the festival and later that evening we were

introduced. I learned that she earned her living through producing handmade earthenware pottery. She also worked with sewing, quilting, crochet and other textile arts. She was an enthusiastic gardener and a student of the classics who could not only recount some of the great classical myths, but she could also translate some of the scientific names of plants and animals. She paid fifty dollars per month to live in a carriage house behind an old mansion. Her rent included a garden space, a garage, an outbuilding (for a pottery studio) and "living quarters" above the garage. It had running water but was not insulated, so she had become adept at soldering pipes, replacing frozen water lines and other minor plumbing chores.

We merrily chatted away about a plethora of subjects, not the least of which was hide tanning. As we talked and laughed together and I looked into her sparkling eyes, I found myself becoming very interested in her deer hide.

Over the next few months, we spent many glorious, visceral hours working hides together. We worked as a team—skinning, making careful incisions, pulling the hides and cutting connective tissue. We marveled at the bare muscular bodies—deer, otter, muskrat, groundhog. Before long we had hides stretched out side by side. We fleshed, stretched and scraped. We applied brains. We pushed and pulled, and we smoked those hides. We marveled as our rough, smelly, raw hides were transformed into soft, buff-colored buckskin with the faint fragrance of wood smoke. Soon we each had a buckskin vest and a deeper connection with each other and the world around us. We still wear our vests, we still have the connection and we are still probing the world together. Stretching and pulling and scraping, pulling back the layers and using brains where we can.

So, in mid-April when I returned to Florida to get my bees, Yanna came along. We had been seeing a lot of each other, but this was the first long trip we'd have together.

We checked on the bees in the orange grove. Sure enough, each hive now had a considerable amount of citrus honey stored, and their populations of workers had built up nicely. In the evening twilight, as the last few field bees drifted back to their hives, we hitched up the trailer, closed up the openings to the hives with

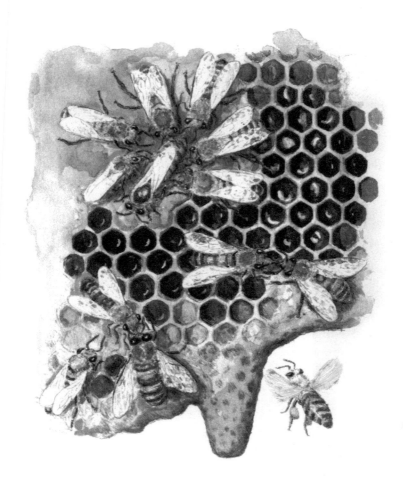

In this illustration of a portion of a honeybee colony, the queen can be seen in the upper left surrounded by her retinue of attendants. They stand on a section of capped cells that contain developing pupae. Moving clockwise we can see the cells containing eggs and the larvae in various stages of development; two workers exchanging nectar (trophallaxis); a worker returning with a load of pollen on her hind legs; a queen cell; cells containing pollen; a drone (with thick body and large eyes) begging food from a worker; and uncapped cells containing honey.

window screening, threw a tarp over the entire contraption and headed out just after dark.

We drove most of the night and ended up at the Griffis place early the next morning. After we got the trailer situated and uncovered the hives, the bees started circling the trailer in ever expanding circles, orienting to this new location, checking out their new environment. By that afternoon, they were flying in and out, bringing in pollen and nectar just like the local bees.

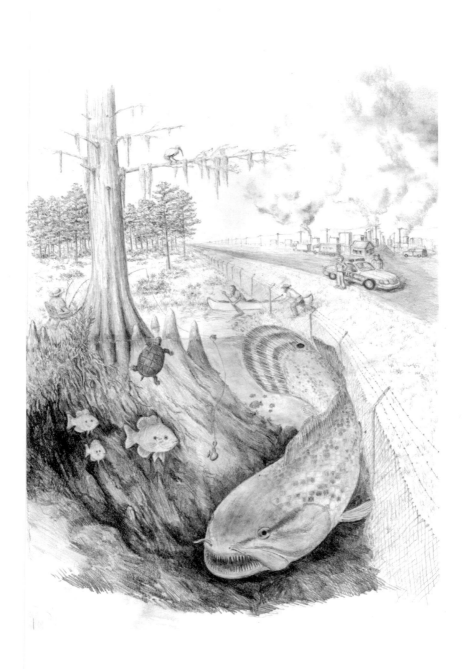

CHAPTER 3

Soul Food in a Southern Swamp

Of Bumming Fish and Crossing Boundaries

As the bees explored their new location, Yanna and I did much of the same thing. We had the canoe, and now we had a couple of weeks to explore both inland Georgia swamps and the coastal barrier islands. The Okefenokee Swamp was first. *Okefenokee* is reputedly a Native American word that means "land of the trembling earth," and it is a vast, watery wilderness—a mysterious and amazing place with miles and miles of wetlands. The tannin-stained water is the color of dark tea. There are moss-draped cypress trees, water lilies, pools, canals, alligators and wading birds everywhere. The dark waters are home to a huge amount of aquatic life, including many species of fish. Fishing is a favorite activity there.

I like a fresh fish dinner, especially when I'm traveling and camping out. But going to a new area and catching fish is not always easy. Fishing is not usually as simple as just putting a line in the water and pulling in fish. Successful fishing often entails a great deal of skill and knowledge—knowing the area, the tides and the seasons; what kinds of fish are available; what kind of bait to use; and how to fish the bait. It usually involves a deep sense of place.

Another consideration is a fishing license, which is required in many areas. An out-of-state license can often be expensive, sometimes twenty or thirty dollars. If you are living on a subsistence budget, that's a high price to pay for a hypothetical fish dinner.

So when I am visiting a new place, I usually don't fish, but I still love to talk to fishermen. Over the years, I have inadvertently discovered a good way to get to eat a lot of fish dinners; I have become an unabashed practitioner of the fine art of fish bumming.

Most fisher folks are generous. If they are successful and have caught many fish, they are often glad to share some of their catch. Sometimes, the catch might be just one or two fish, which many fishermen feel are hardly worth cleaning and taking home. They don't want to waste them, however, so they are often delighted to have someone take those fish off their hands. If you are camping out, even a few small fish are enough to make a nice camp supper.

As we canoe along, I'll often ask the fishermen if they are having any luck. Whatever they answer, I lay out a loaded hint, "If you get too many now, let us know, we can always use a fish dinner where we're camping." Often on the way back, in the afternoon or evening after people have been out all day, is the best time to ask.

There in the Okefenokee Swamp that warm spring day there were a lot of people fishing. We had paddled a good ways out into the swamp, and on the way back we noticed a boat with two Georgia "good ol' boys" at the edge of the canal. One man was at each end of the boat, and they were intently fishing, dropping their lines down in among the bonnet lily pads.

"Hey fellows, you catching any?" I asked.

"We're getting a few—nothin' too much."

"Well, if you get too many now, let us know."

"We have got a couple of these ol' mudfish," one of them said. "You don't want them, do you?"

"Mudfish? What are mudfish?"

"Well, they're just these big ol' swamp fish," he said.

"Are they good to eat?"

"Nah, we don't eat them," he said, "Now, the black folks do…"

I thought to myself, soul food. I never had soul food I didn't like. Sweet potatoes, greens, rice, beans, corn bread, fish and chicken—that's what we eat at home most of the time anyhow. That sounded good to me.

"Yeah, I'll take them," I said.

We pulled the canoe over, and they tossed those two fish over to us. Let me assure you, these fish were a sight to behold. The larger of the two was about a foot and a half long, and what a beast! The fish was shaped like a huge wood-splitting wedge, with a large fan-shaped tail and a long eel-like dorsal fin that ran all the way

down its back. It was a brown-black brindle color, and it looked like the primordial ooze congealed, condensed and personified. It was the concentrated essence of swamp. The body was covered with hard, armorlike scales. Beady, expressionless eyes leered blankly from either side of the broad, thick head. Beside each nostril were little tentacles like catfish whiskers (called barbels). The mouth was wide—like that of a catfish—except that it had jagged rows of curved, snaggly teeth. This was a beast to be reckoned with.

I was a little taken aback. "This is quite a fish," I said breathlessly. "You say you don't know how to cook them?"

The fellow in the bow of the boat said, "No, we don't eat 'em. I don't know how to cook 'em." But the guy in the back interrupted, "Oh yeah, Daddy had a mudfish recipe."

"Can you tell me?" I asked eagerly.

"Yeah, but it's sort of complicated. You got a good memory?"

"Yeah I guess so. Here, I'll write it down," I said, grabbing my notebook.

"Now what Daddy said—you get you a nice clean pine board, a nice soft pine board, and you take that board and then squeeze a bunch of lemon juice on the board, then some barbecue sauce, then a layer of thin slices of onions on that board. Then you split that fish open, and you stake him to that board and then you lay some mo' onions on top and brush some barbecue sauce on top of that; then some

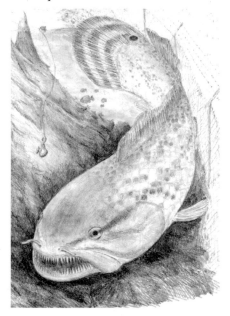

The mouth was wide—like that of a catfish—except it had jagged rows of curved, snaggly teeth. This was a beast to be reckoned with. The mudfish is more properly known as bowfin, or grinnel (*Amia calva*).

ketchup and some soy sauce, red pepper and black pepper, then some crushed garlic. Then you prop it up right there in front of the fire and cook it slow until it gets really cooked through—sort of dry and crispy like. Then when you're sure it's really well done you scrape the fish off and then you eat the *board*!" he sputtered, no longer able to contain his mirth.

"Oh, come on, you guys!"

I sure took that bait—and swallowed it hook, line and sinker. They thought it was hilarious. Here I was, taking notes! So, I said, "Thank you, gentlemen, for the good advice. I'll take these fish, hunt me a board and see what I can do." As we paddled on down the canal I could hear them not so quietly guffawing, "He 'uz writin' down the recipe! Haw haw haw!"

As we were paddling back, I wondered who would tell me how to deal with these fish. How would I learn?

Back at the landing dock, the place was bustling with activity. There were some tour boats going in and out and other canoes and motorboats coming in. There were dock boys in attendance and concessionaires behind the counter. I looked around the area. I didn't want to get made fun of again, but I wanted to find someone who could tell me how to cook these fish—someone with traditional, local wisdom.

Then, all of a sudden, I noticed—over on a little peninsula at the edge of one of the canals—a large African American woman. She was sitting there in a folding chair, wearing a flower print dress and a broad-brimmed straw hat. She had a cooler with her lunch on one side of her chair and a fish bucket on the other side. (In the Okefenokee, you can't leave your fish on a stringer in the water because the gators will get them.)

She had three cane poles propped on the bank in front of her. I thought, Oh, there she is. She has been sitting there all day in silent, focused contemplation of this vast watery wilderness before her. Those fishing poles are like long, highly sensitive antennas, probing the depths, bringing home sustenance—food for herself and her family. Oh, she is the elder, the crone, that wise woman I have been looking for. She would know how to cook a mudfish.

Soul Food in a Southern Swamp

If I could only get her to reveal this ancient wisdom. No harm in trying, I thought. I'll just go and ask her. So I started walking over to her. She was about fifty yards away, and I could see her look up and notice me heading toward her. There was nothing else over there that I could have been walking to, except her. She looked around and adjusted her fishing poles. Then I saw her glance back in my direction, only to see that I was still coming. I could almost hear her thinking, "Now what does that white boy want with me? Oh, he's still coming, oh Lord!" She busied herself again with her fishing poles. I approached her as respectfully as I could, and in my best southern drawl, I said, "Excuse me Ma'am, do you know how to cook a mudfish?"

She peered out at me suspiciously from under the brim of that hat, and she said, "How?"

I could imagine her thinking to herself, "If this boy wants to tell you how to cook a mudfish, let him tell you."

I said, "No Ma'am, *I'm* asking *you*. I don't know. They gave me a couple of mudfish, and I thought you might know how to fix 'em and maybe you could tell me."

When she realized what I was asking, her entire demeanor changed. She said, "Oh son, they ain't hard to cook. They good!" she said with a smile. "Now you gotta skin 'em. You cain't scale them. You skins 'em like a catfish. Then you just takes 'em and you steam 'em. Das right, you poach 'em in a pot till the meat gets cooked, then you take a fork and you take all the meat off the bones, and you take some pepper and you take an egg and some onions and a little bit of corn meal and flour and you make fish balls, and you fry 'em. They good," she reiterated. "They good as a mullet!" (How's that for a standard of excellence?)

I thanked her profusely. We hurried back to our camp and made up a fine meal of south Georgia soul food mudfish balls, and they were better flavored than the finest fancy crab cakes or salmon croquettes that I have ever had. With a few well-placed questions, we managed to bridge a cultural gap and cross a boundary, and we were richly rewarded.

Later on that trip, when we were by the ocean, I saw two men fishing down the beach a ways, casting into the surf, and I headed

down the beach to talk to them. I just wanted to learn what they were fishing for and see if they were catching any fish. These guys had surf-casting rods and were making beautiful, long casts way out beyond the breakers. They were two young black guys. They seemed friendly enough, and the way they were casting, it appeared that they knew what they were doing. All of a sudden one of the rods bent, he set the hook and he started reeling.

Before long he brought in a good-sized ocean catfish. It was a silvery blue-grey color, almost two feet long and had a long top fin and a deeply indented tail. This was a gaff topsail catfish. With a long trailing barbell from its dorsal fin and delicate "whiskers" trailing from it lips, it is probably the most elegant and graceful member of the catfish family.

The fisherman unhooked the fish, but he didn't take it to his cooler up on the beach. He just tossed it right down into the shallow water at his feet and it started to swim back.

"You don't want your catfish?" I said as I ran over and grabbed the fish before it got away.

"No, we're trying to catch sea trout and whiting."

"Do you mind if I take this?" I asked.

"No, you can have that thing if you want it."

I stayed around for a while and he caught a couple of sea trout, and then he caught another catfish. I got the catfish. By the time I

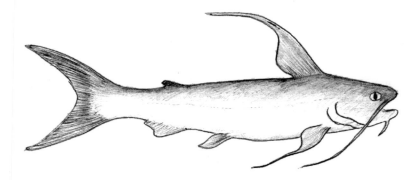

The gaff topsail catfish (*Bagre marinus*), with its long delicate "whiskers," is probably the most elegant and graceful member of the catfish family.

finished hanging out with them, I had three catfish. I skinned and cleaned them, and back at camp we started a fire. I skewered those fish on a stick, we cooked them over the coals and we sat on the dunes and had a fish dinner while listening to the surf and watching the sky turn a golden color as the sun set. Those fish tasted great. As I was picking the last of their bones I couldn't help but think, "What if someone had asked those two fishermen if the catfish were any good to eat?" They probably would have said, "Nah, we don't eat 'em. But them ol' white hippies do…"

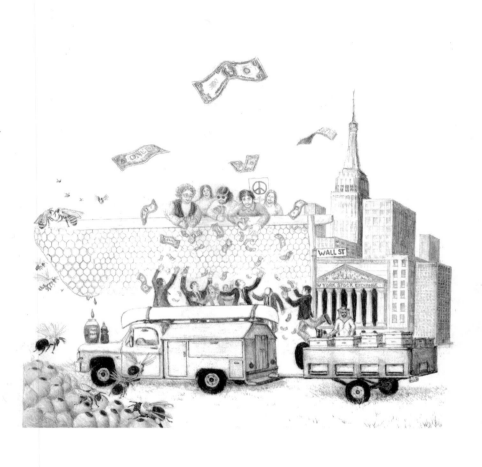

Honeybees in a Corporate World

*Of Honeybees, Yippee Protesters and
the Military Industrial Complex*

He that has not money in his purse should have honey in his mouth.
—French proverb

As I looked down at my hives from up in that poplar tree, I couldn't help but think about my ambivalent relationship with corporate society. While knowing that I reap many benefits from corporate innovation, I was also considering the irreparable damage that irresponsible multinational corporations are doing to our world.

Then I realized that my honeybees are multinationals. They are native to Europe, Africa and Asia. They were imported to North America by early settlers. The first European honeybees on record to arrive in North America were sent by the Virginia Company in the winter of 1621. They were shipped along with fruit trees, seeds, pigeons, dogs, rabbits, peacocks and, some reports say, "57 young maids" to make wives for young planters.[2] There was a lot of potential sweetness in that shipment.

Native Americans soon noticed these new insects and called them "white man's flies." Reflecting on this Indian name, John Burroughs, the great nineteenth-century naturalist and philosopher, wrote:

> *In fact she is the epitome of the white man himself...she has the white man's craftiness, his industry, his architectural skill, his neatness and love of system, and above all, his eager miserly habits. The honeybee's great ambition is to be rich, to lay up great stores, to possess the sweet of every flower that blooms. Enough will not satisfy her, she must have all she can get.*

And that is why we keep bees—because, as Burroughs points out, they are insatiable. They never have enough. They always want more. They will gather and store three or four times more than what they need to live well and survive the winter. That is why we get to eat honey.

"A honeybee colony resembles a big corporation that goes after the big markets," writes Bernd Heinrich in his book *Bumblebee Economics*. "[Because of its large capital investment] it can wait out long lean periods and rapidly exploit windfalls because of its elaborate organization and huge communal storage capacities," he wrote. "In contrast a [native] bumblebee colony has a more individualistic cottage industry approach. It thrives by living hand to mouth, exploiting small, scattered energy sources that in most cases can be taken up by single workers operating individually."[3] A strong colony of honeybees can have a population of eighty thousand workers, while a strong bumblebee colony might have but a few hundred bees.

As marginal, funky, un-corporate and out of the mainstream as I might have appeared with my old Dodge truck and homemade wooden trailer with beehives on it, was I essentially just another manifestation of the corporate mentality?

Onboard my trailer, each hive was like a corporate processing facility—a refinery, of all things—where nectar is processed and refined into honey and wax. In some ways I was just another exploitative capitalist CEO bringing in ten multinational minicorporations with a cheap labor workforce, numbering in the thousands, to exploit the native wildflower bloom in a corporate grab of the resources. These workers would visit every flower for miles, sucking it dry with no regard for the native bees, beetles and butterflies. As soon as the honey flow was over, I would haul my bees away to exploit the next wildflower bloom.

We don't really know how native insects are affected by honeybees utilizing the opulent nectar flows from tree blooms like tupelo and tulip poplar, but the impact is clear in blueberry areas of Maine. When honeybee colonies are brought into the area, Heinrich notes, the native bumblebee colonies are eliminated.[4] They are literally starved out in the same way that small mom and pop family

Honeybees in a Corporate World

businesses are starved out when the Wal-Mart Supercenter moves into town—or in the way that small villages of native peoples are displaced, losing their homes and their cultures, when their forests are cut down by multinational corporations.

Can honeybees provide us with a mirror of ourselves? We humans do seem to identify with bees. We are very different from these tiny, buzzing, instinct-driven, six-legged insects, but we do have a lot in common. Both bees and humans work hard. We both store wealth and manage to live in large, complex societies, and we actively communicate with other members of our society.

We humans have rules that we live by and so do bees. Those of us who keep bees have learned that we can have dominion over them only if we follow their rules. These rules keep their society together and working smoothly. But occasionally, in human society and among the bees as well, the rules break down, and looting and stealing occur. When this happens in the apiary it is known simply as "robbing."

When there are plenty of flowers in bloom and the bees are working a bountiful nectar flow, there is an unmistakable contented hum in the apiary. The field bees are busy flying in and out, bringing in their loads of nectar and pollen. The bees in the hives are busy manufacturing storage cells, storing the pollen and evaporating and processing the nectar into honey. A heavenly, floral fragrance wafts from the hives, and when carried by gentle breezes it can be smelled for a considerable distance.

If there is a stiff breeze blowing and there is a line of similar-looking hives in the apiary, sometimes a returning bee will be blown off course and fly into the wrong hive by mistake. This is called "drifting" by beekeepers. Nobody (none of the bees) seems to notice when this happens. Even the bee that's in the wrong hive seems unaware. It just goes in, dumps off its load of nectar and flies right back out. No big deal.

There are guard bees stationed at the entrance of the hive, but the guard bees only intercept robbing bees. Unlike the bee that is mistakenly bringing in a load of nectar into the wrong hive, bees that have thievery on their "minds" act strangely. They

actually wiggle and shake, like they are nervous, and they are immediately recognized by the guards, who rush out to intercept them and drive them off, ensuring that everything stays orderly and calm.

However, a peacefully working apiary can change drastically in just a few minutes if the beekeeper leaves out some uncovered honey. Honey is the end product—the profit from all their labor. Honey is their sustenance and their security. They need honey to survive, and they will work together long hours to make and store it. (It has been calculated that a hive collectively flies fifty thousand miles and visits more than two million flowers to make one pound of honey.) Honey, to the bees, is a lot like money to humans. Honey/money sustains us. Having some honey/money saved up can help us make it through hard times, yet this same honey/money can corrupt us and make us crazy!

If the bees get access to uncovered, unguarded honey, they will gorge on it and fight over it; they will even drown in the honey. They will madly start drinking it up and bringing it back to their hives, and when that honey is gone, they will start flying around manically, looking for more honey, anywhere they can get it. The contented hum in the bee yard turns into a desperate, angry, high-pitched whine. Chaos reigns. They will rush into neighboring hives—hives they had been living peacefully next to for years. They will crash through and overwhelm the guards at the gate. They will charge into the interior of the hive, find the honey stores, rob that honey and carry it back to their hive. Soon all the hives will join in the melee and start robbing one another. An apiary in a robbing frenzy is not a pretty sight. If there is one hive that is weaker than the others, the robbers will gang up and steal every bit of honey in that hive. The robbed-out colony will be left with no stores, and if it's late in the season, it will starve and die.

The only way a beekeeper can stop a robbing frenzy is to reduce the size of the hives' entrances so that only one or two bees can enter at a time. This enables the guards to regain control of their entrances and do an apian security check on each bee as it comes in, thereby eliminating gate-crashers.

Honeybees in a Corporate World

As I think about the chaos that a robbing frenzy brings to a bee yard, I can't help but remember back in the sixties during the Vietnam War protest era when Abbie Hoffman and the Yippees were active in demonstrations and creative street theatre.

Hoffman and his merry band of malcontents panhandled money for several weeks until they had accumulated hundreds of dollars in small bills. Then they booked a tour of the New York Stock Exchange. As part of the tour in those days, the visitors were taken up on the balcony that overlooked the trading floor. It was a heavy trading day. Even though there was a war going on and hundreds of people were being killed every day in Vietnam, things were lively and bustling at the stock exchange. They gazed down at the trading floor from the balcony through the haze of tobacco smoke from fat cigars and chain-smoked cigarettes, and they marveled at all of the activity below. There were clusters of animated people crowded around various posts on the floor. They were holding up little pieces of paper, waving and gesticulating. These were the floor traders, engaged in bidding. Specialists at each post were managing

the bids, gesturing at the floor traders and notating sales. Runners scurried between the floor traders and the phone banks on the walls, bringing new orders and hurrying back to the phones to report executions of trades to the brokers. Reporters and research analysts busily circulated around the floor, watching trends, trying to keep their home offices abreast of the pulse of the market. A huge ticker tape machine on the wall was cranking out reams of paper, recording every transaction. The place was a beehive of activity. Each individual worker was playing his tiny part in this huge, complex process—this grand unfolding of destiny.

Then the Yippees started throwing money—handful after handful of small bills, hundreds of dollars, started fluttering down like autumn leaves, and as soon as that money got near the floor, chaos erupted. People started pushing, shoving and grabbing at the money and the entire stock exchange was thrown into chaos. The world economy actually paused for a moment while people

dressed in fine business attire fought one another over those mighty dollar bills. It was the best street theatre of the whole Vietnam War era.

In case you want to try this yourself the next time you book a tour of the stock exchange, I should warn you that the security has been tightened. Like beekeepers, the administration of the stock exchange has reduced the entrances, and like the guard bees in the hives, they also do security checks—and they keep a special eye out for people carrying large wads of small bills.

There you have it—money and honey—they are powerful commodities indeed, embodying the promise of sweet security to those who possess them. Unguarded honey in the bee yard creates the same kind of chaos as unguarded money in the stock exchange.

We beekeepers try to sell our honey for a profit. That's the idea anyway. After my migratory bee enterprise, I extracted some of the nicest honey I have ever had, and I did sell some of it. As far as monetary profit…well, I didn't even cover my expenses. I profited in knowledge and experience. I had adventures with my sweetheart, the memories of which still nurture us. Of course my workers still got their salaries. They received healthcare benefits and housing. They got to taste varieties of nectar and honey that stay-at-home bees would never even dream of, and so did we. Their bottom line is that they had enough honey to last them through the winter. My bottom line is really this story line.

Bees provide us with delicious sweets and useful wax. Bees are essential for pollination of our crops and are good for thinking about, too. If we pay enough attention to bees, we might learn something about ourselves.

I don't know if I will ever be able to assess the environmental impact of keeping bees here in America, but it sure does illustrate the complexity of living on earth. It is a reminder that everything we do has an impact—every footstep makes an impression.

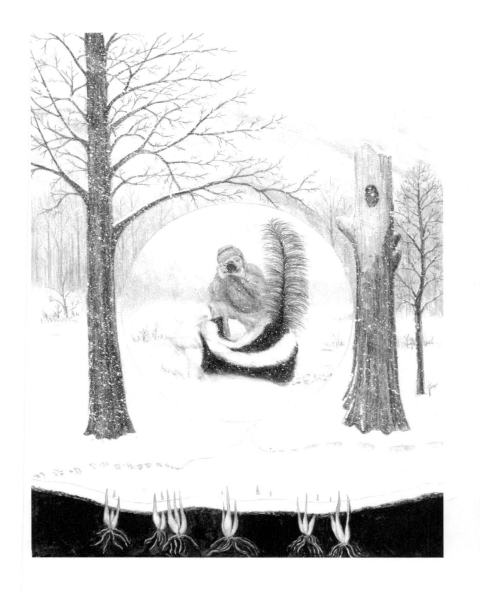

Footprints in the Snow

On the Trail of the Creator

I long for you so much I follow barefoot your frozen tracks that are high in the mountains. I long for you so much I have even begun to travel where I have never been before.

—Hafiz

From the branches of that poplar tree, as I was thinking about impressions and footprints, I looked north toward the higher mountains and remembered an adventure I had on one of those peaks in early spring.

It was the middle of March. Winter was all but gone, and we had seen hardly a flake of snow the entire winter. Now I'm not the sort of person who would complain about a mild winter, but I just had a hankering to tromp around in some snow. Without a little of the white stuff I just don't feel like I've had a winter. In the same way I used to migrate south to get an early taste of spring, this year I found myself heading to the higher mountains to get a last dose of winter.

I love a good tracking snow. My favorite is a snow that's not too deep or powdery, with just enough moisture in it to leave a good imprint. I love trying to decipher the stories that tracks in snow can tell. The first day or two after a snowfall can be such a revealing time to be out in the woods. In summer, you might get a fleeting glimpse of an animal as it leaps away and disappears into the brush. In the wintertime, though, if there is a good tracking snow, even though you may never actually lay eyes on the critter, by studying its tracks you can be with that animal for hours. You

can see everything the critter did. You can see its interactions with the environment. You can follow along and find where it changed direction or speed. You can see where it fed. If it's a predator you might see where it caught its prey; if it is a browser you can discover what plants it nibbled. You can even taste the same plants. You learn where it was going and what it was doing, and you begin to understand its life. Tracks are like stories, and you can just follow along; they will lead you off through thickets and mire, into mountains and deserts, on classic mythic journeys—journeys into the great narrative of life.

If I can't get a tracking snow, however, any snow will do. A cold front was blowing in from the northwest. There was no snow in our forecast, but some accumulation was predicted for the higher elevations. This might be my last chance. If the snow wouldn't come to me, I figured I would head for the snow. I drove up into Avery County to roam the high, forested slopes and grassy balds of the Yellow Mountains.

Even though the first flowers were in bloom at home, here on this mountain only some sixty miles away (and three thousand feet higher) there was indeed a blizzard blowing. The ground was already covered with snow and there was more coming down—glorious, blustery winter weather—just what I came for. With the snow accumulating like it was, I knew my chances of finding animal tracks were slim; but on the other hand, if I did find any today, they would be fresh.

After wandering up the slope a ways, I noticed some familiar-looking dried stems and the tightly rolled tips of green leaves poking up out of the snow. Ramps! Those odiferous, flavorful, wild leeks that mountain folks are so

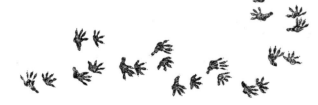

fond of gathering in spring. I had gathered plenty of them in late April and May, but I had no idea that they first appeared in March. I scraped away the snow and unearthed a few. The leaves were tightly compacted. Each plant was no longer than three or four inches from the slender, pale white bulb to the pointed green top.

I wiped them off in the snow and munched a few right there on the spot. They were crisp and tender—about as mild as a ramp could be—but *whoa*! That hot, musky, powerful, oniony-garlic flavor still made my eyes water. Young as they were, these babies still packed a wallop.

I kept on climbing up through the woods, reveling in the snowy bluster and munching more ramps as I went. I spent the rest of the day wandering all over those wintry mountain slopes. As I was heading down, I was thrilled to come upon a set of tracks. These were similar to a groundhog's, with a waddling gait, but the trail was narrower and the feet were smaller. I followed them down through the woods until they came out to an open meadow. At this point, the snow was blowing sideways and the surrounding mountains were lost in dim whiteness. I pulled my cap down and my scarf up around my face in a vain attempt to keep the snow from blowing in behind my glasses. The tracks meandered about in the field. The feet were delicate and squirrel-like, with long front claws, but the creature didn't have the bounding gait (or habitat) of a squirrel. It was ambling around in the field. I followed along, totally fascinated, wiping my glasses as I went. Here and there were small, cone-shaped holes and fresh dirt where the animal had been digging. Could this be a skunk? I wondered. "Yes," I gasped. In fact, there the skunk was, right in front of me, not thirty feet away. It was ambling along, vigorously digging at the edge of grass clumps and rooting about. I had been so absorbed in my tracking, and the skunk was so focused on its food gathering, that I had almost walked right up on the critter and neither of us knew the other was there. The skunk was busy hunting grubs, ants and other hibernating insects, as well as an occasional vole or mouse. With the snow accumulating as it was, this was the last chance for a short-legged critter to easily dig up some food until the snow melted. Skunks do not actually hibernate, but they will "lay up" in their dens for several days at a time during severe weather.

I stopped right there in my own tracks and ever so slowly hunkered down. With the animal so close and still unaware of me, I remembered that opportunities like this were the reason I had been toting my camera with the zoom lens. I eased my pack off my shoulders and somehow extracted the camera without alerting the skunk. I zoomed in as close as I could get, focused and fired off a couple of shots as the animal worked its way across the field, coming closer and closer. The gusty wind was blowing in my face as I watched the skunk pass below me on the slope. It was about fifteen feet away when suddenly it looked up and stared right at me. Its nose nervously probed the air. With one eye in the viewfinder and one eye peeking over the top of the camera, I froze like a statue while the skunk stared at me long and hard. Skunks have poor vision, and in this shadowless, dim light, if I could hold still enough I might escape detection and pass for an inert (if slightly weird) part of the landscape. It would never catch my scent with this strong wind blowing. And if I could get the camera focused and defogged at the same time, I might even be able to get a half-decent photo.

Never taking its eye off me, the skunk slowly and suspiciously lifted its tail. Then suddenly it started bounding in my direction. I couldn't believe what I was seeing (split image as it was). A charging skunk! Not only that, it was charging at me! I frantically tried to adjust my focus for the rapidly decreasing distance between us. I held my ground (and my breath) while my adrenaline ran wild. The skunk ran right up, and mercifully, it came to an abrupt halt five feet away.

I could see it squint its beady black eyes and sniff again. With the wind blowing, it still couldn't smell me and had no clue as to my identity. Then it whirled around and ran off a few yards, circled around to my left side and ran up to me again. Again it sniffed, but the wind was still strong, and blowing from the side this time, so the skunk still could not get a whiff of my human scent. Then it ran off again. This time it circled around up the hill until it was directly downwind of me. It stood up on its haunches and sniffed again. Being directly downwind this time, it caught my scent with both nostrils. That poor astonished critter shook its head and snorted. A shudder seemed to run

Footprints in the Snow

I zoomed my camera in as close as I could, focused and fired off a couple of shots as the skunk worked its way across the field.

The skunk was charging me!

down its body. Then it whirled around, ran off down through a blackberry thicket and dove into a burrow. I guess the moral of the story is: eat enough ramps and you can beat a skunk at its own game.

This encounter started me thinking about nature study in general and skunk tracking in particular as a metaphor. That skunk was so focused on gathering sustenance that it was oblivious to my approach, and I was so focused on the details and subtleties of this small yet great narrative of life laid out before me that I forgot to consider the teller of the story, the creator of the tracks.

I pondered what that skunk experience has to say to someone who sees the natural world as a manifestation of God. Can one be so intent on studying these manifestations of the Creator and be so focused on the details that he would not even notice the Creator—not be aware of the big picture? Is this about not being able to "see the forest for trees"?

Or is it more, as Kabir said, "You shall never find the forest if you ignore the trees." One cannot know the forest without knowing the trees. If you thoroughly and carefully study the trees, you will come to know the forest, and likewise maybe if you carefully study

the tracks—those imprints or impressions left by the Creator—you will indeed learn much about the one who made those tracks. If you choose to follow the tracks far enough, you will eventually arrive at the One who made them. You may actually come face to face with the Creator—or possibly, like me, blunder into the creator's rear end. That might truly change your reality, leaving you enveloped in a cloud of enlightenment!

The Ramp or Wild Leek

Long before planting time and well before the leaves emerge on the trees, the green wisps of the wild leek (*Allium tricoccum*) poke through the leaf litter on the forest floor. This odiferous member of the onion clan is found in rich forests east of the Great Plains from Canada, south into the higher mountains of the southern Appalachians. Anywhere these plants grow, they have been appreciated by country folks (and a few urban gourmets) as a valuable spring vegetable.

In the North they are known as wild leeks, but south of the Mason-Dixon line they are usually referred to as "ramps." This strange name is a remnant of an early English dialect word that has survived in the semi-isolated communities of the southern Appalachians. Like many of the inhabitants of the region, the word comes from the British Isles, where it originally referred to the British bear leek (*Allium ursinum*), which was commonly called the

"ramson." The Swedes are credited with naming the plant ramson or "son of the ram," because the leaves first appear under the sign of Aries, the ram, between March 20 and April 20. Over the years "ramson" was shortened to "ramp."

While ramps are still much celebrated for their food value and flavor, they are more notorious for their powerful odor. The smell is like that of strident onion or garlic combined with a singular powerful muskiness all its own.

The opinion of the midwestern Menominee Indians on this score is reflected in their name for the plant. In their language, ramps were called *pikwute sikakushia* or "skunk plant," and the rich woodlands near the southern edge of Lake Michigan, where the wild leeks were particularly abundant, was called *shikako*, meaning "the skunk place." This is supposedly where the fuming, seething metropolis we now know as Chicago gets its name.

As powerfully odiferous as the plants are when eaten raw, I find them easily tamed by cooking, and they can be used any way that you use onion or garlic. (For more on ramps, see *Wild Roots* and *Woodslore.*)

How to Pick up a Skunk

Skunks thrive in almost all parts of the continent except the extreme north. Their only specialty is their highly evolved (and extremely accurate) musk glands. With one gland located on each side of the anus, a skunk rarely misses. While looking straight at you, the skunk can swing its rear end around and fire away! As powerful as this spray is, the quantity is limited to about five or six shots. Perhaps because of this, or simply because of its mellow temperament, a skunk shows restraint and would much rather avoid a confrontation. When it first senses danger, a skunk will try to retreat, waddling away with its characteristic, ambling gait. If it is still molested, it then gives warning. The striped skunk may stamp its front feet on

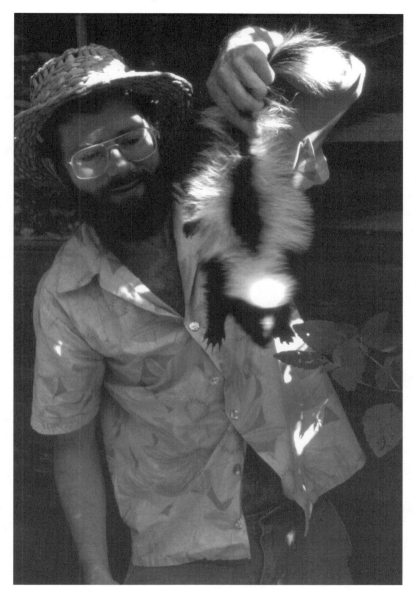

It really is possible to pick up a skunk by the tail.

the ground, growl, hiss or click its teeth. The acrobatic spotted skunk may even do a "hand stand" when agitated and walk about on its front legs. Then up goes the tail—straight up like a magnificent, bushy plume. This is the moment for you to head for the hills! In a flash the skunk whips into its U-shaped battle position, its head and rear on target, facing the enemy. It can shoot up, down, left, right or straight ahead. The gorgeous tail is held daintily aloft, as the skunk would not want to soil its own fur or block the carefully aimed stream of spray.

The two vents of the glands protrude like twin nozzles as the powerful hip muscles contract and squeeze two fine streams of oily, yellowish liquid toward the target. These streams merge about a foot away from the animal into one spray of very fine droplets. This spray is aimed at the face of the attacker and is amazingly accurate up to about twelve feet. If the wind is right, the spray can actually carry six or eight feet more.

If the spray gets into the eyes, it will burn like fire, but it does no permanent damage. Flushing the eyes with fresh water will hasten recovery, but even without this, the stream of tears will wash the spray out within ten or fifteen minutes. (That's usually enough time for the skunk to be long gone.) I have talked to a number of folks who have caught an eye-full of skunk spray. Though they all agreed that it hurt at the time, many of the victims believe it has actually improved their eyesight!

It really is possible to pick up a skunk by the tail without getting sprayed. I have done it several times. In order to spray, a skunk must hold its tail at a right angle to its body. When being held by its tail, the tail extends straight back and the skunk can't spray. Of course, it is difficult to approach a skunk close enough to grab it. I have only been able to do this when the skunk is partially concealed and thinks it is hiding. You must grab the skunk's tail firmly and swiftly lift it off the ground. There are no second chances in this game! Once you are proudly holding the skunk by the tail, the next question that will occur to you is, "How do I put it down?!"

If you find yourself in this position, just give me a call. I'm in the phone book, and if you don't get my answering machine, I'll be glad to tell you!

Footprints in the Snow

Seriously, though, all you need to do is toss the skunk with a gentle underhand swing so that it lands about ten or fifteen feet away. It usually lands on its feet, and in an unruffled, dignified manner, it will calmly walk away. (But if it doesn't—run like hell!) For more skunk stories see *Wildwoods Wisdom.*

Tickled by Trout

Of Good Ol' Boys, Fish Grabbing
and the Handwriting of God

In the previous chapter we considered how tracks across the snowy landscape are like a script that tells a story. There are so many scripts in nature. In his 1867 work, *A Thousand-Mile Walk to the Gulf*, John Muir referred to nature as a great palimpsest (a piece of paper that has been erased and written over many times):

> *When a page is written over but once it may be easily read; but if it be written over and over with characters of every size and style, it soon becomes unreadable, although not a single confused meaningless mark or thought may occur among all the written characters to mar its perfection. Our limited powers are similarly perplexed and over taxed in reading the inexhaustible pages of nature, for they are written in characters of every size and color, sentences composed of sentences, every part of a character a sentence. There is not a fragment in all nature, for every relative fragment of one thing is a full harmonious unit in itself. All together form one grand palimpsest of the world.*

I remember the time I was living in my little cabin up in the mountains and the phone rang. I picked it up and heard an enthusiastic, youthful drawl, "What're you doin'?"

I said, "Oh, I'm here at the house. Who is this?"

"It's Chris. Come on man, let's go to the woods. Bruce and me are heading to the mountains. You want to come with us, man? We know a holler way back in there where hardly anybody goes. It's some pretty country, buddy, you wanna go with us?"

"Yeah man," I replied. "Let's go."

Chris and Bruce were two young local guys. I was in my late thirties at the time, and these guys were in their early twenties. They were overgrown teenagers—wild mountain guys into rowdiness, fast cars and various other forms of socially unacceptable behavior. For some reason I got along pretty well with them. The thing that I particularly enjoyed about them was that they loved to roam the woods. They were strong and vigorous and knew lots of great places to explore, so I was always glad to go out with them. I felt like it was an honor to be asked. So, we went to a trailhead and started climbing up the mountain.

"On the back side of this mountain," Chris was saying, "we're gonna drop down into a little holler that hardly anybody knows about. There's some clear water, buddy, it's purty as can be in there."

When we finally got to the summit, we came out on a grassy bald. A grassy bald is an open mountaintop meadow of mysterious origin that is characteristic of many high mountain peaks in the southern Appalachians. Because the open sunny habitat on top of the mountains is so different from the surrounding wooded slopes, one can see many plants that are not found in the shade of the surrounding forest. I couldn't help but notice that there was a large population of wild angelicas that were forming seeds. The seeds have a strong, spicy taste. They are in the same family as dill, caraway and coriander. Sometimes I'll use a few angelica seeds in curry or rice dishes just to give a wild native flavor. So we paused and collected a little bag of seeds.

Then we headed out of the meadow and down into the special holler that the guys had been telling me about. A holler (more properly, a hollow) is like a crease in the mountain—a valley between two ridges. At the head of the holler, there are little seepy areas where springs come to the surface. As you move downhill, they run together to form what Appalachian folks call branches, and the branches flow together to form a creek. The farther down you go, the larger the creek becomes. We meandered along, exploring the woods and working our way down the creek. Chris had gotten ahead of Bruce and me, and by the time we caught up to him, the creek was a couple of feet wide, bubbling down over the rocks.

Tickled by Trout

We found Chris at a pool about the size of a bathtub that formed where the water poured over a rock ledge. He was at the lower end of the pool busily piling rocks, blocking up the stream, like he was trying to dam up the pool.

"Boys," he said excitedly, "I seen two trout in there. We're gonna get them trout. One was a good-sized one, too. They're right in there!" Whereupon he reached into his pocket and pulled out his pistol. He pointed it at the pool and was about to shoot when I said, "Chris, have you ever heard of tickling a trout?"

He gave me a strange look. Now, to tell the truth, I had never really tried tickling a trout (and I'm sure it was no more legal than shooting one). I had only heard of it from a friend who lived in the Catskill Mountains and claimed that he used to catch trout that way. He told me that when you come up to a small trout stream, you can feel around up under the bank or in protected spots under rock ledges. If you feel a trout, you can calm the fish by ever so gently caressing it, moving your fingers like gentle currents of water, and then when the trout is in the right position you can quickly grab it.

Chris looked at me, "Tickle a trout, Doug? You're telling me you're gonna tickle a trout?"

"Let me just try, before you start shooting," I pleaded. "It won't hurt to try. I just heard-tell of this, and this little pool would be a perfect place to try it out."

I had heard that you were supposed to hold your hands in the stream until your hands and fingers are cool like the water. So I held my hands in the creek until they were plenty cold. Then I reached carefully into the middle of that pool and started feeling around—the first thing I put my hands on was the back of a trout.

I said, "Boys, I feel one. I feel one right here!" While they watched, I ever so gently moved my fingers along its soft, silky body. I slowly slid my other hand into position and *grabbed*—and I came up with a thirteen-inch trout.

I could hardly believe that I actually had a trout in my hands. It was a native brook trout, the brilliantly colored southern Appalachian variety that the mountain folks call "speckled trout." A speckled trout fresh out of one of those cold, clear mountain streams is one of the most beautiful things in the world. The

underside of the belly is as white as a new fallen snow, and at the edge of that pristine belly is a wavy jet-black line. It looks like some ancient Chinese master had touched it with a fine-pointed calligrapher's brush. The black and white meet in two fine lines at the leading edges of the lower fins, and from there the fins and the belly become bright red, with the red exploding into a brilliant blazing orange that looks like the dawning of a new day or like a glorious, fiery sunset. And in that crimson orange blaze are bright yellow speckles that look like the first stars off in the far universe, twinkling at the edge of blue-gray and purple twilight. There is also a sprinkling of red dots with hazy bluish-purple halos around them that look like other worlds—red planets with ethereal, gassy-blue atmospheres. The sky melded into a mottled, mossy yellow-green that looks like a dripping creek bank in a lush, sun-dappled woodland glade. The yellow speckles there in the dark areas seem like the first fireflies flickering on a warm summer evening. It was as if the entire universe was here on the flank of this trout. The trout's back was covered with incredible black markings—wormlike squiggles that looked like intricate hieroglyphics that might very well spell out the wisdom of the ages.

I was astounded. Right here before me—the heavens and the earth, the trees, the flowers and the waters had come together and congealed into this resplendent being quivering in my hands.

Then I hear, "What're you doing!? Come on, get that trout in off the creek here. He's suffering while you're standing there slack-jawed staring at him. We gon' eat that trout, so let's put him out of his misery and don't make him suffer!"

That snapped me out of my reverie. They laid the trout on the bank and twisted its head back. The trout quivered once and then went limp. As the life left that trout, I could see the colors begin to fade, almost before my eyes.

I was astounded by what had just happened. I was overwhelmed by the gift of this trout and overcome with its immensity—the raw yet elegant, refined beauty, the majesty of this being that I had actually lifted from the waters with my own two hands.

Chris said, "That's one."

"That's one?" I asked weakly.

Tickled by Trout

"Yeah, I told you I seen two trout in there. Now you get the other'n!"

"Oh...yeah...well, I'll see what I can do, boys." Now I was the expert. So I reached back into that pool and started feeling around, and before long, sure enough, I felt another trout. It was tucked up into a little crevice. I reached in and caught that second trout, which was almost as large as the first one. We got that trout on the bank, twisted its head back and laid it with the other one on the mossy bank beside the creek. I just couldn't believe that I had caught two trout with my hands.

"Here, try this pool," Chris said from down the stream a ways. "Try this pool right here."

I felt around but found nothing.

"Now try this pool right here," said Chris, moving on down farther, "and this pool..." They worked me down the stream, sort of like a bird dog, or should I say like a fish dog. In a few other pools, I actually did feel some smaller trout, but I didn't say anything. I just let those trout be, because those were the ones that would move into and take over the pool that I had just vacated.

I was so excited. I wanted to take the big one home and measure it. (I did, and it really was thirteen inches.) We cleaned the other trout, built a little fire and cut a fresh green spicewood (*Lindera benzoin*) sapling.

We skewered the trout on the spicewood, crushed a few angelica seeds and sprinkled them in the body cavity. When our fire burned down to coals, we slowly and carefully cooked it over those coals. When it was done, we laid the fish down on a large leaf, where we opened it up and carefully pulled out the bones. The meat was moist, pink and beautiful, and the flavor was incredible. We could taste the sharpness of the angelica spice and a touch of the aromatic bouquet of the spicewood where the stick penetrated the meat. It was like a sacrament that we shared there in the woods, a true communion.

I never quite recovered from the beauty of that fish, fresh out of the water like that. Sometime after that, I was hiking in the backcountry along a good-sized clear stream in West Virginia. I had binoculars, a small pack on my back with some snacks and my

sketchbook. I had no place that I had to be that day. I was living right. I wasn't fishing, but with that stream right beside me I was thinking about trout.

I saw a deep pool, and there was a trout not far below the surface, holding its position in the middle of the pool. It was facing upstream, occasionally coming to the surface to snatch a floating insect and then return to its place. I stayed low and didn't spook the trout. I just slowly sat down right there in the tall grass on the bank and watched with my binoculars. Through the binoculars, I could see the trout clearly, like it was practically in my lap. I could see the white leading edge of the lower fins, so I knew that it was a brook trout. On its back I could see those distinctive, characteristic wormlike markings—incredible, intricate patterns on the living fish right in front of me. Then I realized that I had my sketchbook right there. I would try to sketch the trout. Drawing those patterns would be a great way to study them. So for the next hour or so, I just sat there with my sketchbook. I would look with the binoculars, then draw a little bit, then look with the binoculars and draw a little more. I was starting to capture some of the details of the pattern on that trout's back. It was starting to look like some kind of writing—an elegant hieroglyphic script, or some beautiful calligraphy—maybe like Sanskrit, Chinese or Arabic, with those graceful loops, squiggles, swirls and dots.

I kept thinking, whose writing is that? That's got to be God's handwriting, Wow! God's handwriting right there on the back of that trout! If I could figure out how to read God's handwriting, think of what I could learn.

That started me on a mission. Every time I had a chance to take a photograph of a trout, I would work up a drawing from the photo, study the pattern and try to see if I could decipher the figures and determine what they said. One time, my friend Billy was looking at one of these trout pictures on my drawing board. I explained that I was studying the pattern. I was telling him that I figured that the pattern was God's handwriting, and I wanted to know what it says.

It turned out that Billy had studied Hebrew, and he said, "Well, actually, it looks a little like Hebrew. See the 'hey' (ה) right there,

that's an *H* sound and with that dot, and then the 'olif' (א) there—that kind of makes it sort of a prolonged *E* sound there. Actually what it says there is, 'Hee, Hee, Hee, Hee, Hee, Hee'— all the way down the trout."

Eureka! There was my answer! It's a giggle. It's a chuckle. That *is* profound! Profound divine laughter. What is revealed here in this sacred script is the divine sense of humor—a revelation of the great cosmic joke of which we are all a part.

This was hardly the end of my mission, because whatever I might be able to decipher on the back of this one small trout was, of course, only a miniscule part of the infinite message of Creation. And each trout has a different pattern. Wow, a different message on each trout! So I continued taking pictures every time I caught a trout. I would get the photo enlarged, take the enlargement to the copy center, make a photocopy of the picture and study the pattern. I would get out my fine detailing paintbrush and enhance the image. I would make the darks a little darker and the lights lighter to make the script clearer to read. For me it was a way of studying the will of the Creator—of opening myself to the mind of God.

One time I had gone to a copy shop in town to get a run of my brochures printed. When I came back to pick up the brochures, I had a few of those trout pictures to copy. The man who ran

the shop was a friendly, conservative-looking guy, probably in his forties. He was admiring my brochure, commenting how we liked a lot of the same things. He started telling me about how he loved to get out into the woods, and he recounted various adventures he'd had. We swapped some stories for a while. Then I asked about the copy machine.

"Sure it's working fine," he said. "What have you got?"

I showed him the eight by ten glossies of the trout.

"Oh, man, those are nice trout," he said admiringly.

I confided that these photos were actually close-ups of small trout about four or five inches long. Then I thought, I'm just going to tell him what I'm up to, just to see what he says. Sometimes if you are forthcoming and just "put it out there," you never know what you'll get back. So I proceeded to tell him that I was studying the pattern on the back of the trout.

"That pattern looks like handwriting to me," I said. "If it's handwriting, it's got to be God's handwriting, and if it's God's handwriting, I want to read it. I want to know what it says."

Without missing a beat he said, "Yes sir, Brother. I know what you are talking about. I read the Bible a lot. Sometimes I'll get up in the middle of the night—in the wee hours of the morning—and read the Bible by candlelight. When I get a passage that speaks to me and I really want to study it, I'll read it once to myself, and then I'll read it once out loud, and then the third time I'll say, 'Alright God, now you read it through me.' That third time, you can feel it. You can feel the power of the Lord moving right in there with you. You can feel it!"

"Boy, that must be something," I said.

Then he looked me in the eye and said, "You seem like a brother. I guess I can tell you this. Up behind my house, there is a big patch of national forest land up there, and I like to hike way back in there, and up on the ridge top there is this big flat rock. That rock is one of my favorite places in this world. What a place for inspiration, what a place for meditation and prayer—you can look out there at one mountain after another fading off in the distance, they look like waves of the ocean, frozen in time. I go up there every chance I get. One time, I went up there after I had been reading the Old

Testament in Exodus, about Moses, when he saw that bush burning right in front of him. The bush was burning but it wasn't consumed, then he heard the voice of the Lord. The Lord said to him, 'Moses, take thy sandals off they feet for the ground upon which thou standeth is holy ground.' I was thinking about that scripture, and I got to thinking about where I was standing, and I thought, if this isn't holy ground, I don't know what is. So I sat down right there, and I hauled off my boots and my socks and I just stood there with my bare feet on that rock.

"Talk about holy ground. You could feel it. I could feel the power of the Lord coming right up through me, right up out of that mountain. Well I don't know what came over me, but you know what I did next? I pulled off my shirt, hauled off my pants and took off my underwear, my wristwatch. Everything. I just stood there. I wasn't wearing a thing, and I just put my hands out, and I said, 'Lord, this is the way I came into the world, and this is all I've got and it's all for your service.' I could just feel the Lord coming right on in, running all through me."

"That must have been something," I said.

Then he said with a grin, "Couldn't you see God up there in heaven, saying, 'Hey, Peter, hey, Gabriel, come here, look at this fellow down there, he's hauled his britches off now!' I bet they got a good laugh out of that, don't you think?"

"I think they probably did," I agreed, thinking to myself that their laughter probably sounded like "Hee, Hee, Hee, Hee, Hee, Hee."

Angelica—A Useful Herb (and Some Dangerous Look-Alikes)

The angelica seeds that we were gathering on the mountaintop were from *Angelica triquinata*, so named because the leaves are usually divided into three groups of five leaflets. Angelica is in Apiaceae, the parsley family, formerly known as the Umbellifers because the flowers are arranged in an umbel (i.e., all the stems of the flower cluster radiate from a single point at the end of the stalk, like an

umbrella). Many of the plants in this family are useful. Just look in your pantry: dill, fennel, caraway, coriander, cumin, carrots, parsnips and celery. But here's the catch: this family also contains a few of the deadliest plants in North America—the poison hemlocks *Cicuta*, *Conium* and *Aethusa*, also known as "fool's parsley." *So it is imperative to positively identify any member of this family before you ingest it.*

The angelicas have a number of uses. The seeds, roots, stalks and leaves have been used to make a stimulating aromatic, bitter tonic to treat colds, flu and digestive and menstrual irregularities. The Asian *Don Quai* root (*Angelica polymorpha*) is a famous remedy used as an antispasmodic uterine tonic to treat menstrual disorders. In Europe, along with these medicinal uses, the young shoots of *Angelica archangelica* have been candied as a confection and sometimes cooked and eaten with rhubarb. American species tend to be too strong-flavored for casual eating, though I occasionally use a few seeds as an aromatic spice.

Spicebush, a Shrub of Many Uses

Spicebush (*Lindera benzoin*) is a medium-sized shrub found in rich, moist bottomlands throughout much of eastern North America. Known as "spicewood" in the southern Appalachians, it is used in many ways. The aromatic twigs can be boiled to make a fragrant, flavorful tonic tea (sometimes combined with sassafras and sweet birch). Medicinally it has been used to treat cough, flu and fevers, and also as a digestive tonic. The twigs are used to flavor meats and fish, and the leaves and twigs can be parboiled with wild meats to moderate the gamey flavor. The bright red berries are known as "American allspice" and are gathered in autumn, dried, ground and sprinkled on apple dishes, pastries, stir-fried rice and vegetables, meats and other dishes for an exotic-tasting, native flavor.

Spicebush (along with sassafras) is the birthplace and larval food of the spicebush swallowtail (*Paplio troilus*), one of the large black butterflies with the distinctive "swallow" tails on the hind wings. The caterpillar of this handsome butterfly is adept at mimicry. When it is small, the larva is glossy with a smeared brown and white coloration, resembling nothing more than a bird dropping. When it gets larger and the bird dropping subterfuge would be less convincing, the larva turns green and resembles the head of a snake with two large black and yellow eye spots. The larva remains concealed during the day by folding a leaf around its body with silk, but they can be found by carefully inspecting a spicebush or sassafras and searching for curled-up leaves.

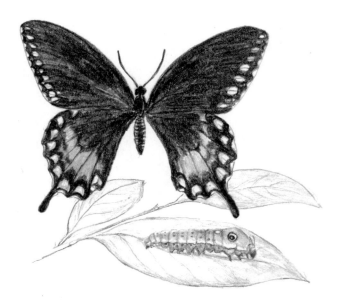

Republicans in the Ramp Patch

Of Possums, Politics and Smelly Wild Onions

D oug, I got you a 'possum," Lee said. Even on the phone, I could immediately recognize his familiar mountain drawl. "You want 'im? He's a fat 'un."

Lee lived a few miles down the road in a little mountain community named Bee Log, North Carolina. He and his wife had befriended me when I was living in the area. Lee would call me whenever he caught a 'possum. He kept chickens, and it seemed like he regularly had a 'possum raiding his chicken coop. He would either catch it live in a box trap or he'd shoot it when his dog treed it in the yard. When someone calls me about a 'possum, I feel duty-bound to answer the call.

I never knew what condition the possum would be in when I arrived, whether it would be alive, "grinning" and snarling at me from the box trap, or lying there dead. If it was alive, we would stuff it into a sack or a crate. I'd say, "Thanks, Lee, that 'possum'll be good eating." And then I'd take it out into the national forest and let the poor thing go. If he had already killed the 'possum, I would take it home and cook it.

Lee considered himself too affluent to eat 'possum. Almost every visit he would show me his shelves of canned goods and his two freezers crammed full of deer, beef, chicken, pork and bear meat. Even though he wasn't planning to eat the 'possum, he always had a lot to say about the subtleties of possum cuisine. He wanted to be sure I prepared it properly.

I can remember him holding a particularly robust (but dead) 'possum by the tail, practically salivating as he pinched the hind

legs, saying, "Now look at the fat hams on this critter, Doug. Now if you want to cook 'im right, git you a mess of spicewood [*Lindera benzoin*] twigs. Cut 'em with your knife so they're sharp, and then when you get that 'possum all skinned and cleaned, stick them little twigs in the meat and fill him up, buddy, till he looks like a little porcupine. Then you parboil him till he's tender. See, them twigs'll cut the gamey taste and give the meat a good, spicy flavor. Then bake him in the oven with some sweet taters all around, buddy, you gonna have some fine eating."

I did just as he advised, and he was right. That spicewood-flavored 'possum meat was mighty fine eating. Since that time I always try to use spicewood whenever I cook wild game.

One time in early April I got a call from Lee. This time it wasn't about 'possums. He said, "Doug, my wife's going to her daddy's to fix him Sunday dinner. Let's you and me go to the ramp patch, dig some ramps and eat our dinner in the woods."

Lee was not active in church, but he often liked to do something special on Sunday mornings, so we would often go to the woods. He was what is known as a "yellow dog Republican." I'd hear him proclaim, "I'd vote for a yaller dog before I'd vote for a Democrat." I knew better than to discuss religion or politics with him. His affiliations in these areas were beyond discussion; they were as much a part of him as his rich mountain accent.

We didn't need to speak of religion, as far as I was concerned. Our Sunday mornings on those high mountain slopes—rooting out those powerful wild leeks from the rich black earth, with the wildflowers blooming all around us and the spring sun shining through newly bursting leaf buds—was about as profound a religious communion as I could imagine. I remember one ramp expedition particularly well.

"I baked us a cake a' corn bread," said Lee when I arrived at his house that bright spring morning.

"I got some cheese and crackers," I replied.

"What else do you want? I got some hot dogs," he said, holding out short cans of Vienna sausage from his pantry shelf. "Or how 'bout some sardines?"

Not being attracted to nitrite-laden pork byproducts, I quickly said, "I reckon them sardines'd go pretty good with ramps."

Republicans in the Ramp Patch

"I believe you're right," he said, slipping two cans of sardines into his pack.

Since the ramps grew at higher elevations, the beginning of our ramp-gathering expeditions started with a significant climb through old homesteads and pastures up to the rich, moist, thickly forested north-facing slopes where the ramps grew.

As we hiked up the mountain, we passed little seepy areas from which springs emerged and formed the beginnings of the creeks. Every time we would pass one of these seeps, Lee would stop, locate the place where the spring emerged from the ground and rake away the leaves, mud and other debris to form a little pool that would eventually clear.

"That way," Lee said, "if we come back by here later, that water will be clear and clean. Or if somebody else comes by here, they can get 'em a drink of clean spring water. That's my trademark, Buddy. If you're walking through the woods somewhere, and you find a little spring like that and it ain't been cleaned out, you'll know, 'Lee ain't been thar.'"

When we got well up on the mountain, we started seeing the first ramps. Their tender green leaves were poking up through the forest

duff. There was a spring coming out from under a large boulder. Lee immediately went to work cleaning it out. "Let's leave our packs and our dinner stuff right here," he said. "We'll take sacks for the ramps and head up the mountain. There's some big ramp patches up yonder. When we come back here, the spring'll be all cleared out and we'll be able to get us a drink of water with our dinner."

We dug ramps here and there as we climbed. Up higher the ramps grew in lush green patches as thick as any planted garden bed. We moved around as we dug, being careful not to deplete the ramps in any one area. We gathered not only for our lunch there on the mountain but also to bring a load of these incredibly flavorful and wholesome vegetables home. Some would go fresh into meals for the next week or so, and the rest would go into the freezer for off-season eating.

Some people can eat considerable quantities of raw ramps. I do occasionally nibble fresh, raw ramps in the woods, but like garlic or strong onions, I usually prefer them when they are tamed by cooking with other food or sliced thinly on a sandwich.

When we got back to our "dinner place," the water in the spring had cleared. We sat down, pulled our food out of the packs and started munching away. A chunk of ramp on cheese with a cracker tasted great. Then we had ramps with corn bread and ramps with sardines. Lee opened his can of sardines, pulled out a plastic fork and proceeded to stir and mash the sardines and sliced ramps together in the can.

"I'm making me a hash," he said with obvious relish. "Whenever I come to the ramp patch, from now on," he said, "I'm bringing sardines. They sho' go good with these ramps!"

When I finished eating, I went over to the spring to get a drink. The water was crystal clear, flowing out of the ground into the pool with a gentle current. I got down on my knees, put my head down to the water, pursed my lips and drank deeply from the center of the pool. That spring water was so cold and so fresh. As I swallowed, I felt as though it was moving into every cell in my body, lubricating, refreshing and rejuvenating. When I had my fill and stood up, the entire world around me seemed to scintillate with vibrant, clear energy. I felt like I had a new perspective on life. "Now that's some mighty fine water," I said.

Republicans in the Ramp Patch

Lee got up and took a drink. "Now I wish Reagan could be here with us and have some of that water," he said when he sat back down.

This took me aback and left me reeling somewhat. I had been trying to avoid discussing politics. Here we were in deep communion in God's wilderness, and now he says he wants Ronald Reagan (who was president at the time) to be there with us. Reagan was the guy who said, "A tree is a tree. How many more do you have to look at?" when he was opposing the expansion of Redwood National Park. "If you've seen one, you've seen them all," he proclaimed.[5]

Shortly after Reagan appointed James Watt to be his secretary of the interior, Watt reportedly told the U.S. Congress that protecting natural resources was unimportant in light of the imminent return of Jesus Christ. He was quoted as saying, "We don't have to protect the environment; the Second Coming is at hand."[6] In the meantime, Reagan was assuring the country that "trees cause more pollution than automobiles do."

Now I may be a bit narrow-minded, but I have always been somewhat of a one-issue voter. I generally believe that a politician's morality, vision, leadership and concern for future generations are demonstrated through his, or her, environmental policies. After all, what good are winning wars, economic prosperity and domination of the rest of the world if we don't have clean air to breathe, clean water to drink, natural resources left for future generations and some undisturbed wilderness in which to contemplate the miracle of creation? Ronald Reagan was not anywhere near the top of my list of people I would have invited to be with us there on that mountain that day.

I recovered enough to ask weakly, "Now why would you say that, Lee?"

"Just 'cause I'd want him to have somethin' good," Lee replied sincerely.

After quietly muttering, sputtering and raging to myself for a moment, I realized that though I might be appalled at the idea of invoking this person who I saw as an enemy of the environment, an experience like this with Lee in the ramp patch might indeed be just what Reagan needed. I thought about how nurtured and enriched

I felt by being there. Here on this mountain, I was lifting these marvelous wild vegetables out of the rich earth and drinking that miraculous spring water. I felt revitalized, nourished and changed by this experience. I thought, "Yes, Lee's right. I agree. I wish ol' Reagan could be here with us too."

So now when I'm in the woods gathering ramps and wild greens, drinking pristine spring water, admiring an exquisite wildflower or witnessing a glorious sunset, I often find myself saying, "I wish Reagan (or I'll substitute the name of one of the contemporary politicians who still continue Reagan's shortsighted environmentally destructive legacy) could be here with me now."

After I had moved away to my present home in Rutherford County, North Carolina, I would still stop in on Lee when I was back in the area. Lee's wife had died, and he was getting older and having some medical problems. When I visited, I would help him with various chores. Sometimes it was garden work, and sometimes it was chain sawing or moving heavy items.

One time he called me and asked me to help him with his bees. For many years he had kept several "stands" of bees up on the hill behind his house. In the last few years, however, he had not been able to work with them and the bees had died off. But this year, wild swarms had moved into two of his abandoned hives; they had made a fair amount of honey, and he wanted me to help him harvest his honey. I brought bee suits, a smoker, tools and my friend Dale to help out. Lee was getting rather tottery, but his spirit was still as strong and determined as ever. He had always worked his hives wearing regular work gloves and a crude bee veil that he had made out of window screen and canvas.

As frail as he was, I wanted to reduce the chance of him getting stung, so we dressed him up in one of my modern store-bought bee suits (coveralls with a zip-on helmet and veil). It took both of us to get him up the hill to his hives. But once there, he actively supervised while we opened the hives, took off the honey supers, loaded them in a wheelbarrow and brought them down to the house. Then he worked with us all afternoon while we cut out comb and bottled the harvest.

Republicans in the Ramp Patch

As we worked, I wondered about my priorities. It seemed like during this period of his life Lee was aging rapidly and losing a lot of his abilities. He regularly needed rides to the doctor and help with various things. What few family members he had were not living nearby. I lived far away, too. His local neighbors and friends gave him rides and looked in on him regularly. I had never taken him to the doctor, yet I had driven all that distance to help him mess with his bees, of all things! Did that make sense? Yet as I thought about it, I realized that here was an aging, moderately independent mountain man—a farmer, woodsman, homesteader and beekeeper. When he had asked me to help him work his bees, what he was really asking was for me to help him continue to be who he was. I felt honored to be able to answer that call.

He gave us each a couple of jars of the honey for our day's work. And on a later visit that fall, he sold me the remainder of the honey we had harvested. That was the last time I saw him. He died a few months later.

My family, friends and I still roam the high mountains to gather ramps and other wild plants. When I come to a little seepy area where a spring flows out of the ground and I see that the spring has not been cleaned out, I'll say to myself, "Lee ain't been there."

The Hunt

Bambi Is Alive and Well

There is no plan when it comes to hunting power. Hunting power or hunting game is the same. A hunter hunts whatever presents itself to him. Thus he must always be in a state of readiness.

—*Don Juan/Carlos Castaneda*

When our son, Todd, was in his tenth year he got interested in shooting a rifle. I took out the old .22-caliber rifle that has been in the family, and we started having backyard target-shooting sessions. I had never thought too much about that .22 until one time a few years after my dad died when I was visiting an old friend of his in Louisiana. The old gentleman asked me, "What happened to that .22 of your grandfather's?"

"I have it," I said.

"My boys learned to shoot with that gun. I guess you and your brother did too, didn't you."

Well, yes, we had, and now my son was learning on it. So I guess a deadly firearm really is a part of the family heritage.

We went squirrel hunting one morning and shot four squirrels. Todd shot his first. It was a rite of passage of sorts. After a squirrel fell from the tree, we'd usually pause and say, "Blessings on you," as we picked the squirrel up, trying to honor its death in some way. I was wondering if I should have "blooded" him like the upper-crust English fox hunters who ritually smeared the blood of the fox on new members of the group as an initiation rite. Somehow, I couldn't manifest that kind of ritual (I'm too low class, I reckon), but he helped skin and clean them so I guess it happened anyway. He tanned one of the hides until it was very soft and flexible. He

couldn't figure out what to make with it, but he would occasionally wear the hide on his head, wave the tail and bark like a squirrel.

When Todd was a baby, as soon as he was able to ride around in a seat, we acquired one of those aluminum-framed, nylon child-carrier backpacks. I was looking forward to taking him on long walks in the woods, but it did not take long to realize that those carriers are made for walking on sidewalks, lawns and open areas. In thick woods, the branches, brush and brambles were a hazard. No matter how careful I was, he would regularly come back with scratches.

We loved going in the woods together, so by the time he was two years old, I rigged up a pack basket made of ash and oak splints with a waist belt and shoulder straps, and it worked wonderfully as a child carrier. Todd loved it. He could stand up in the bottom of the basket, hold on to the rim and ride along like a little charioteer, taking in the scenery. I trained him to squat down "on command" and pull his head in, like a turtle in a woven shell; then I could push through thickets and brambles, and he was protected from scratches. I would say, "Duck down Todd!" and he would squat down in the basket and pull his head in. I carried a rearview mirror so I could look over my shoulder to be sure he really was down. With him tucked in the basket, I could push through whatever thicket, and when I would get to a clear area, I would say, "Okay Todd," and he would stand up and say, "Whew!" and off we would go until the next thicket.

One day our neighbor Polly gave us a large platter of raccoon meat. She had cooked it all night on the wood stove and then fried it in a spicy batter, and it was still warm when she delivered it. It was tender and delicious. We were not eating much meat in those days. Todd loved it. Every morning Todd would go to the refrigerator and ask for it, saying, "Coon?" He may not have acquired much of a sweet tooth, but this kid sure did have a meat tooth. Yanna and I had both been vegetarians at various times in our lives, and we were somewhat distrustful about consuming commercial meat, but now that she was a full-time milk producer, she was really enjoying the concentrated doses of protein from the occasional piece of wild meat that did come our way.

The Hunt

So with my wife and baby craving meat and deer season approaching, I decided to dust off my grandpa's Winchester .94, 30-30 saddle carbine rifle—another family heirloom. I cleaned and oiled the gun. I went to town, bought some ammunition, a hunting license and a blaze orange vest and a cap. As I was bustling around making all those preparations, Yanna asked, "Are you sure you're a hunter? Our hunting friends usually give us meat," she reminded me. "And we often find fresh road kills. Don't you want to just wait and see if some meat just comes to us like it often does?"

"Yanna, if I go sit in the woods and a deer actually walks by and I shoot it, I would consider that as 'meat just coming to us,'" I said.

I hadn't shot that rifle since I was a teenager. However, our neighbor was a gung-ho deer hunter. He had targets all over his backyard and a table with sand bags set up for sighting-in rifles. He invited me over to practice target shooting. His targets were about thirty yards away. I had done a fair amount of shooting as a teenager, and after a few shots and a couple of adjustments on the peep sight, it seemed like I could get it to shoot within an inch or two of where I aimed, and my shots made a fairly tight pattern at the center of the target. Once I got it sighted in, it didn't seem necessary to shoot more than a few times. (The cartridges cost fifty cents apiece and the gun kicked like a mule.)

The day before deer season opened, I wanted to go up on the mountain behind the house, scout for deer sign and find a good place to make a stand. I also wanted to make a prayer offering to the deer. I had been talking to some Native American friends, and I had been reading a great deal about traditional ways that native peoples view the game animals that feed them. Many cultures believe that if the hunter shows a proper amount of reverence and respect for the life and the spirit of the animal that he or she is hunting, the animal will actually come and offer itself to the hunter. That sounded good to me.

I loaded Todd up in the pack basket, since he was always up for an adventure in the woods. I carried my little deerskin medicine bag, too. In my medicine bag I had herbs that I had collected and carefully dried. Among them were cedar, sage, sweet grass and tobacco.

We got to a small flat spot up on the ridge and sat down. I thought about how I might attune myself to the deer. I once asked a Native American teacher about how one might prepare for a hunt. He told me that in his prayers when he addresses the deer spirit, he is talking to what they call "Real Deer," or what might be called the spirit of "deerness." He gives thanks and asks for a manifestation of this "deerness" to come within shooting range and help feed his family.

"What about the Great Spirit?" I asked.

"It's all a part of the One," he said. "And besides," he commented, "'Great Spirit' might be a mistranslation. We really call it the 'Great Mystery,'" he told me, "because of course, this creation we are a part of is a mystery, more than our human minds can comprehend."

I offered tobacco and burned it with the other herbs. I promised to come into the woods with an open heart and be as respectful as I could should one of the deer clan come offer itself within rifle range. Todd watched everything.

I snuffed out the coals, loaded Todd back in the basket and continued scouting. I followed a deer trail up the ridge, watching for fresh sign and looking for a good place to wait the next morning. I found a perfect stump that I could lean back against. It overlooked the trail that passed thirty yards below and had a good view of the surrounding area. It would be a lovely place to try to meld into the background and to witness the dawning of a new day while waiting for a deer.

After a while, I took a shortcut down through a laurel (rhododendron) thicket. Well, it turned out that the slope was quite steep, and the rhododendrons were growing densely. The best way to descend through one of these steep thickets is to slide on your butt. There are usually lots of soft leaves to slide on, as well as branches and trunks to hold onto so you can control your speed. It's usually quite fun, too. Safe and fun as it may be, this was not the style of travel to which young Todd was accustomed. As we slid down the hill, he let out an anxious, plaintive moan. "Noooo!" he protested. "Mama," he cried. "Home!"

I kept trying to reassure him and make light of the situation, saying things like, "It's fun, Todd! We're sliding down the mountain! Hooray! Uhhh, duck down, Todd. Heh, heh."

The Hunt

He was not comforted in the slightest by my shaky reassurances. I knew I had to get him out of there as fast as possible. I did not want to make my son afraid to go into the woods with me. I kept sliding and trying to calm and reassure him while trying to figure how I was going to get him down the mountain and out of the thicket without completely traumatizing him. Right then a springy branch caught my eyeglasses and flung them off my face as I slid by. There I was, sitting in a huge pile of newly disturbed, loosely piled leaves in the middle of a laurel thicket, with Todd plaintively pleading, "Mama!...Home!" I had no idea where my gold wire–rimmed glasses had flown. Not being able to see very well, I felt around, attempting to be careful and systematic in my search for the glasses while simultaneously trying to reassure Todd, who was about to lose it completely.

Priorities being what they were, I finally had to give up searching, and we slid the remaining distance out of the thicket. As soon as I got back on my feet and started walking normally, Todd quickly regained his composure. I marked a few trees so I could find my way back, and we headed on back toward the house.

It seemed strange and unsettling at first to be without my glasses, but after a few unsure moments, I marveled at how much softer the world seemed without them. The shapes and forms were still there, as well as the lights and darks and the colors, but it was all without the crispness and all the sharp details that have become so important to me as an herb gatherer, tracker and observer of subtleties. The disturbed leaves, the creeping insect, the tiny flower, the scratches on the bark, the patterns on rocks and the scat on the trail were all blended now and merged into the soft, amorphous whole. The magic, the mystery and the richness were still there. It was only my ability to focus in on the details that was missing.

The abilities to focus and, of course, to aim are essential to a hunter. Was the cosmos trying to tell me something? Was this a message from the deer spirit? Yanna's question echoed in my mind: "Was I really a hunter?" How could I accurately aim a gun without glasses? Was this a sign that I should not hunt?

Could I find my spare glasses? I wondered. If I could easily find them, maybe this was not really a sign that I should not hunt, I

rationalized. Of course, if I couldn't find them, then there was no way I could hunt.

When I got back home, I found my spare glasses right away. I left Todd home with Mama, and I followed the marked trees back into the laurel thicket. I located that pile of leaves where I had slid, and soon I found my lost glasses.

The next morning I went out before daylight, and I sat all morning in the pouring rain and saw no deer. It turned out that the little house I had built up in the higher mountains in Yancey County years ago was to be vacant for a week or so while the caretakers visited family. Since the deer are very abundant there, Yanna, Todd and I made a pilgrimage.

On the first afternoon, I walked up behind the place and saw a few deer right away. I could hear them crunching the leaves. The woods were very dry, and each step they took made an incredibly loud crunching sound. I wondered how I was supposed to walk into the woods without alerting every deer to my presence. I moved very slowly to a ridge. The ridge had some bare spots where wind had blown the leaves away, so I could very slowly and carefully pick my way up the hill with hardly a sound. I finally crept up a small ridge to a place where I could look into the hollow where I had been hearing movement. I slowly peered over the crest of the hill and saw a deer feeding about eighty yards away, and it was standing broadside to me. I guess this is what I'm looking for, I said to myself. I set the deer in my sights and squeezed the trigger. The shot rang out and I thought I saw the deer flinch, but it didn't go down so I shot again…and then again…and again.

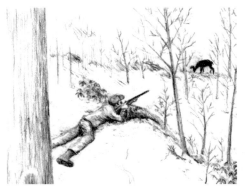

The deer looked around curiously and then lowered its head and continued grazing, its tail wagging contentedly. It didn't even run away! I sat there feeling completely ridiculous. I had more

rounds in the gun, but I figured that if I couldn't even scare the deer with four shots I might as well not bother. I couldn't tell if I had shot over the deer, under it or to either side. I had sighted my gun in at thirty yards, and this shot was more like eighty yards. It was hard to line up that peep sight in the dim light. I watched that deer feed for a while longer till it was almost dark, and then I tiptoed out of the woods. I don't think the deer ever knew I was there.

Shortly after I got back to the cabin, a truck pulled in. A couple of my neighbors had been hunting nearby and heard my shots. They had come to help me skin out the deer. They were quite amused when I told them what had happened. They told me about the old tradition of cutting a hunter's shirttail off when he misses a deer. I told them that I couldn't afford to chop up that many shirts.

The next few days I went out every morning and afternoon and had great adventures, always seeing deer, but I vowed that I wasn't going to shoot unless a deer was practically in my lap. I never had one really close. The last morning, I had just left the cabin before daylight and was walking along an old grassy road that cut across the hill when I spooked some deer in the predawn darkness. I heard one run down below the road into a field and the others ran up into the woods above me. So I slipped up into the woods and sat down, leaning against a tree trunk where I would have a good view along the road.

Before long, down in the field below me I heard footsteps in the leaves and a plaintive, high-pitched nasal bleating. It sounded

The little deer stopped and stared at me.

sort of like a baby goat. I kept hearing footsteps in the leaves coming steadily toward me. Up over the rise came a small deer. It was easily within range, and it was bleating its heart out. This was a late-season fawn. Earlier when I spooked that herd of deer, it had gotten separated from its mother, and now it was calling to her. This was the antlerless season. This deer was legal. And this deer was close! I raised the gun. The little deer stopped and stared at me. I returned the gaze down my gun barrel. The deer bleated again. I didn't pull the trigger. I slowly lowered my gun, and after a few moments, the deer finally caught my scent, snorted and dashed off.

In retrospect, I realized that that was my deer. If I wanted to be like a cougar or a wolf or some other natural predator, this was the deer for me. This was the weakest member of the herd (with the tenderest meat, I might add). This was the one deer in the herd that would not reproduce during the next season. If I wanted to take a deer and make the least possible impact on the population, this was the deer I should have shot. I just wasn't prepared to shoot a deer that was crying for its mama. Talk about a Bambi complex!

During that week, when Todd would ask where I was going, I'd try to explain that I was going out hunting. "Coon?" he would ask. "Well, no, not exactly—hunting for deer—for meat," I would explain.

For several months after that, when Todd would see a picture of a deer, he would point at it and say, "Meat!" We enjoyed many hearty meals of beans, rice, 'taters and greens that season.

Rhododendron

"The best way to get through the laurels," says veteran laurel thicket crawler Clyde Hollifield, "is to keep low like a bear. (When Hollifield speaks of "laurels," like most mountain folks, he is speaking of the large-leafed rhododendron, *R. maximum*. The true mountain laurel, *Kalmia*, is called "ivy" by mountain folks.) "Don't try to think your way down the mountain by looking ahead and trying to plan out a strategy of how you're gonna go. Just go to the next clear place.

The Hunt

And if you think you might have to hike through laurels," Hollifield warns, "whatever you do, don't use a backpack. Carry your gear slung under you, like from a shoulder bag or from your belt, like a fanny pack." A serious danger for trail hikers, according to Hollifield, is "laurel thicket syndrome." He says that backpackers searching for a shortcut down the mountain sometimes get lured off into the middle of one of these thickets: "After about the fourth or fifth hour of climbing through the laurels with a full backpack, when every step you take is thwarted by branches snagging your pack, ripping your clothing and clawing at your face, and you've tried to crawl under branches with your full backpack and your nose has plowed furrows through the dirt underfoot and you've tried to climb over branches and they suddenly give way when you put your weight on them...After a full afternoon of this, toward evening, especially when it looks like rain and it's too steep and thick to pitch a tent, and the laurels still go on forever, a peculiar type of madness sets in—sort of a dementia, I guess you'd call it—that's the dreaded 'laurel thicket syndrome' and it's serious."

So he said solemnly (but with a twinkle in his eye). "People have died from it," he concluded.

It was a laurel thicket–shrouded waterfall that was the demise of University of North Carolina professor Elisha Mitchell in 1857, when he fell to his death on the side of the 6,684-foot mountain that he measured and now bears his name (and his grave).

While a laurel thicket can be the bane of hikers, it is often a boon for wildlife—especially big game animals. Rhododendron leaves are an important source of food for deer in winter, and it is often deep in these thickets where does drop their fawns and bucks shed their antlers. Bears also regularly spend the day and occasionally sleep for the winter in the shelter of a laurel thicket; this is usually where they run when hounded by packs of hunting dogs.

Rhododendrons are the largest evergreen, broad-leafed plants in the mountains, and their leaves are often the only greenery in the winter woods. Some mountain folks can tell the temperature within a few degrees by the condition of the rhododendron leaves. As the thermometer drops, the leaves begin to curl up lengthwise. The colder the temperature the tighter they roll. When the temperature

40′ F

30′ F

10′ F

A rhododendron can be used as a thermometer in winter.

is down below ten degrees Fahrenheit, the leaves will be rolled into tubes as narrow as pencils.

Both rhododendron and *Kalmia* have a reputation for producing poisonous honey. It was reported by a Confederate army surgeon during the Civil War, who witnessed a few toxic reactions. More than two thousand years ago, the Greek historian Xenophon wrote that Greek soldiers were poisoned from honey made from the flowers of a Eurasian species, *Rhododendron ponticum.* Modern beekeepers find little or no problem with this because our native rhododendrons yield little or no honey, and when the *Kalmia* comes into bloom in May, the bees are usually busy harvesting tulip poplar nectar. Tulip poplar is their most abundant and dependable honey source, and when they are working it they seem not to notice the *Kalmia.* In 1990 and 2007, however, in the southern Appalachians, there was a late freeze that killed the tulip poplar bloom, and some beekeepers reported harvesting some very light-colored *Kalmia* honey early in the season. (We harvested hundreds of pounds of it.) As attractive as the *Kalmia* honey looks, it is unmarketable because it has a bitter aftertaste, so it is usually left on the hive or fed back to the bees. The bees seem to thrive on it.

Rhododendron and *Kalmia* have been important to the mountain people in another way. The rustic appearance and strength of this fine-grained wood made it an ideal material from which to

The Hunt

construct a variety of items, from toys such as "whimmy-diddles" and slingshots for children to rustic furniture for the porches of country inns and souvenirs for the tourist trade. These novelty items not only entertained many a mountain youngster, but they also provided cash income for backwoods families.

Of all the rhododendrons, the big-leafed "laurel," *Rhododendron maximum*, is the most abundant. Even though it is not as showy as the pink-flowered Catawba rhododendron or as fragrant and delicate as the azaleas of spring, it is still my favorite. I like the fact that one plant can represent such extremes, depending on your point of view—it can be an "ungodly tangle" or an "impenetrable hell," and it can also be shelter, seclusion and safety, topped off with bouquets of heavenly blossoms.

Donald Culross Peattie described this plant aptly when he wrote:

> *At precisely that season when the shade grows dense and the breath of the valley is hot, when the thrush sings more and more briefly at dawn and after sunset, and all the other of Rhododendrons...have long since bloomed themselves out, the Big Rhododendron at last opens its great, cool blossoms from the immense buds...It is not gaudy or showy* [but]*...for refinement of detail, in form and color, it would be difficult to discover a lovelier flower in the American flora.*

One sultry day this summer, I hope you have a chance to retreat into some shady mountain "holler" and take a dip in a gravel-bottomed pool of a bubbling mountain stream festooned with rhododendron blossoms. When you do, you'll know you're in paradise.

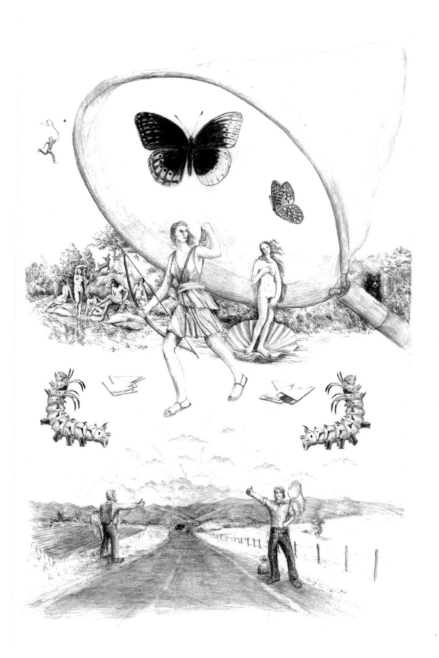

Another Roadside Attraction

The Passionate Quest of the Butterfly Hitchhikers

For many years I went to West Virginia every summer to teach classes in Elkins at Augusta Heritage Arts Workshops. When I teach an outdoor workshop, I try to arrive several days in advance of my classes as sort of a retreat—a few days of quiet time to roam the mountains and commune with nature, as well as an opportunity to scout out the areas where I plan to take my classes.

In the summer of 1990, however, I had been so involved in projects around home that I was only going to have two days before classes. In fact, to give myself a few extra hours, I left home at six in the evening and camped on the road so I could have part of an extra day in West Virginia. The next morning, as I was driving along a rural highway, I spied an interesting-looking older man hiking along the road with his thumb out. He had a gray beard, a small backpack, a warm twinkle in his eye…and he was carrying a butterfly net! When I saw that butterfly net, I came screeching to a halt. No question about it: anyone hitching through West Virginia with a butterfly net is going to get a ride from me. I made room for him in the front seat, and we introduced ourselves. I'll call him Robert.

Before long, we were engaged in lively conversation about butterflies, birds, trees, herbs and insects. He told me about various long walks he had been taking, exploring various parts of the high country. He was staying in a cabin on a back road deep in Monongahela National Forest. This was an area I wanted to explore, and because I was enjoying his company, I agreed to take him home. We stopped several times along the way to look at plants. I got some good photographs of fringed orchids and flowering shrubs. Later

that afternoon, I dropped him off at his cabin. He offered to take me back to some high wetlands that he wanted to explore near the headwaters of the Greenbrier River. This sounded like a great way to spend my one remaining free day, so we made plans.

Late that afternoon, I went to camp at Laurel Fork, a wilderness area where I like to take my classes. I followed a trail along the stream into the woods for a mile or two. It was a mixed habitat of deep woods and old beaver meadows. As I was walking back out, I spied a large, dark form in a low, wet area ahead of me. I froze in my tracks. A bear! It was about thirty yards off the trail with its back to me. It was slowly traveling along through the marshy meadow with its head down, stopping here and there, like it was feeding on something. It gradually moved behind some alder shrubs until I could only see parts of its dark flank through the branches. Breathlessly, I watched, trying to discern what the bear was doing.

Suddenly I saw movement farther ahead about forty yards away in the direction the bear had been heading, and I realized that the bear was already over there. The dark spots I had been fixated on behind that alder had transformed from black bear to dark nothingness while I watched, and I couldn't tell. I was astounded that a several-hundred-pound beast could evaporate like that right before my eyes and then reappear somewhere else.

The bear had moved farther away, but it was still feeding. I really wanted to see what it was eating, so keeping a large hemlock tree between me and the bear, I ever so quietly moved closer. It was fairly easy to walk quietly on the open, grassy ground.

As I crept closer, I thought to myself, "Is this wise—sneaking up on a wild bear in the twilight in the backwoods?" Black bears in the East are shy and not generally considered dangerous to people. But they sometimes kill deer, sheep and cattle. What would I do if it charged me? I wondered. In my mind, I went over a litany of bear confrontation advice: don't run; stand your ground; wave your arms to look large; don't make eye contact. That's what you're supposed to do. But what would I really do if that bear headed toward me?

In the mountains of North Carolina, I've heard the old-timers say that you never have to worry about a bear catching you,

because it's a proven fact that you can run faster on dry ground than a bear can on slick shit. (Haw haw!) My dad used to tell me that if a bear charged, all you had to do was just "stick your arm down its throat, grab and pull real hard." You could turn the bear inside out, and then it would be headed the other way. Joking aside, what would I do?

Suddenly the bear reared up on its hind legs, facing me. The upper half of its body loomed above the waist-high meadow plants. There we stood, staring at each other in a quiet sort of communion, both of us filled with awe and wonder—the bear probably wondering, as it sniffed and squinted in my direction, how a creature so puny-looking could smell so awful. I wondered about the meaning, as well as the implications, of this encounter. We shared a transcendental moment, all right.

Barry Lopez, in his book *Wolves and Men*, observed this intense stare between the wolf and a potential prey animal when they are sizing up each other. He speculated that "what transpires in those moments of staring is an exchange of information between predator and prey that either triggers a chase or defuses the hunt right there." He calls this exchange "the conversation of death."[7] Perhaps a similar, but not so deadly, sort of conversational stare occurs between a driver and a hitchhiker on the road.

The bear let out an explosive snort, turned and dashed away, splashing across the creek and disappearing into the forest. "How I enjoyed the vanishing view of that bear," said John Muir after a similar encounter in the Yosemite backcountry.

As soon as the bear was gone, I went over to where it had been. Its path of trodden-down plants was clear. All along the creek bottom, that bear's trail led from one skunk cabbage plant to the other. It had been feeding on the ripening fruits of skunk cabbage. I tasted a tiny piece of one of the fruits and, like I expected, my mouth began to burn fiercely from the calcium oxalate crystals. Bears' apparent immunity to the arum family's fiery chemical arsenal is amazing. (For more on this see *Wildwoods Wisdom*.)

The next morning, Robert and I started off through a pasture gate following a dirt road. This was clearly private land, but Robert assured me that he knew the owners.

"Some of these farms are so far back in here, they don't have public electricity," he said. "These folks do have cars and they use generators for power, but bless 'em, they retain many of the old values. You don't see many 'no trespassing' signs around here." The area resembled the high mountain grasslands of the West—miles and miles of mountaintop pastures with patches of woods and rocks here and there. We stopped now and then to check out plants. I found out that Robert had a PhD with a special interest in grasses. Before long he had my mind boggled in a flurry of glumes, awns, blades, lemma and other grass characteristics.

After a while, a farmhouse came into view, tucked in at the base of a hill about a half mile away. The farmer was tending to his chores, straddling his modern rancher's "horse," a small four-wheeled all-terrain vehicle. We knew we had been spotted when he revved the engine and headed straight toward us. I felt a moment of anxiety like we had been caught trespassing. The man rode up to us and cut the engine.

"Them butterflies'll 'bout run you to death, won't they?" he said with a friendly grin.

"Oh yeah, they sure will," Robert answered, "but we're looking for lots of other things, too—flowers...birds...herbs...frogs...wild women...whatever we can find."

"Well, we got right smart of most of that stuff you're lookin' for around here, but not too many of the last thing you mentioned."

"That's all right," said Robert. "We're glad to settle for a few butterflies."

Robert asked him about the various grasses, and they got into an animated discussion about the pasture environment. The farmer pointed out different grasses like the poverty grass, growing in the areas with poor soils, and the Allegheny fly-back, which is so named because its flexible stems make it problematic to cut with a scythe. Hearing this botanically trained grass expert and this mountain cattle rancher talking revealed layers of understanding, not only about the various tussocks and clumps at our feet and the differing shades of green on the surrounding mountains, but also about the soil underneath that connects it all.

We finally bid the farmer adieu and headed on our way across the mountain. We strolled along, taking in the view while Robert

swooped his net back and forth. We came to a rocky meadow that was scintillating with tawny, speckled fritillary butterflies. Soon Robert was in their midst, net in hand, swooping in graceful arcs. Before long he was extracting their quivering forms one at a time from his silken snare. He would gently restrain them between his large thumb and forefinger and examine their patterns with the ever-ready magnifying lens that hung around his neck.

"Narrow submarginal band on the hind wing," he reported. "This is *Speyeria aphrodite aphrodite*, a female. This little beauty is the Aphrodite fritillary. She was named for the goddess of love, beauty and desire. The Romans called her Venus. Ah, to possess such fleeting beauty," he said wistfully, "and then to let it slip through your fingers." He released his hold and watched her dart rapidly across the meadow.

We stood at the edge of the field and marveled at the activity. The male fritillaries flitted back and forth a few feet above the ground, patrolling for females. The females fluttered their wings coyly while sipping thistles and daisies. We were all part of one big, shimmering erotic dance—an Aphrodite love fest in a secluded mountain meadow.

Later that evening, after hiking a circuit of over ten miles, we came out at my truck. I felt like I had been transported to other worlds by this gentle, Thoreauvian character who, with few possessions other than his knapsack on his back, his hand lens around his neck and his butterfly net on his shoulder, was able to move with an openhearted grace through these mountains from the side of the highway to the farms of earthy mountain folks and through a plethora of natural environments in between.

Robert and I corresponded regularly that fall and winter. I sent him specimens to identify, and he sent me postcards full of names—scientific as well as common names of various mushrooms, plants and animals that he had been seeing on his hikes. Almost

"This little beauty is the *Aphrodite fritillary*, named for the goddess of love, beauty and desire. The Romans called her Venus. Ah, to possess such fleeting beauty," he said wistfully, "and then to let it slip through your fingers…"

every card had a quote from a poet or philosopher such as Emerson, Twain, Thoreau or Abbey. As the next summer rolled around, I was looking forward to meeting up with him and spending another day or two roaming before my classes started, but it was not to be. I was working straight out on a book deadline, and by the time I was ready to leave I would arrive in West Virginia with barely one day to scout around for my classes. A postcard from Robert told me that he would be traveling in the backcountry and would be difficult to locate in the short time I would have.

So I started my summer tour with a twinge of frustration and melancholy at not having time for my "retreat" in West Virginia and also at being unsure of meeting up with my new buddy. This was my state of mind as I drove through the southern edge of West Virginia on the way to Elkins. Suddenly on the road ahead I spotted a hitchhiker.

No, it was not Robert. In checking him out, as I drew closer, I could see that this guy was a little rough looking—missing a couple front teeth, wearing a funky baseball cap with some day-glow paint on it and having a rattail of long hair extending down to the nape of his T-shirt. In spite of his rough edges, there was an honest directness in his face. As I slowed down, considering whether to stop or not, I noticed he was carrying a partially filled pillow case and…was that? Could it be? It looked like he had a butterfly net! "Oh this is too much," I muttered and pulled right on over. I watched with curiosity through the rearview mirror as he jogged up to my truck. We greeted each other as he climbed in. Strong northern accent, I noticed.

"Don't mind this," he said as he maneuvered a long-handled object into the cab between us. "This is my butterfly net."

"I thought so," I said. "Where you headed?"

"I'm headed over into Virginia, east of here about thirty or forty miles. Gonna do some butterfly collecting in a place called Poverty Hollow. I'm gonna try to catch some of these. Here, I'll show you."

He reached into his pillowcase and pulled out a cigar box. When he opened it, I could see it was full of the triangular, folded specimen envelopes that butterfly collectors use to store and transport their

specimens. He lifted out a large one and read his notations on the fold. "Yeah, July 6th, 1990. I caught this one almost exactly a year ago today. This is the time of year they're flyin'," he said.

He opened the envelope and showed me a large, dark butterfly with a speckled pattern and a four-inch wingspan. I was surprised that I didn't recognize this butterfly. Having been interested in butterflies for years and having collected them in my youth, I can usually identify almost any large eastern butterfly. But this one stumped me.

"It's a Diana," he said. "They're sort of rare and local, but not where I'm going. I been there almost every July for the last eight years. I even lived down there for a year or so," he said.

This was *Speyeria diana*, considered to be the largest and most uniquely beautiful of the fritillaries (*Nymphalidae*)—a real prize for collectors.

"Where you from?" I asked

"Lockport, New York. It's just outside of Buffalo."

"You hitched all the way down here to go butterfly hunting?"

"Yeah, my car would never make the trip. I started yesterday morning. I'm making good time...so far. Where you headed?" he asked.

"I'm on my way to Elkins, West Virginia."

"Elkins! Oh yeah, I been writing to a guy up in Elkins that collects butterflies. He works for the Forest Service. His name is...Tom... can't think of his last name. He caught a bilateral gynandromorph of a Diana. I read about it in the *Lep.* [Lepidoptera] *Journal*..."

"Now hold it a minute," I interrupted. "He caught a what?"

"A bilateral gynandromorph of a Diana."

"What's that?"

A bilateral gynandromorph of a Diana butterfly is an extreme oddity. It's half male and half female. The male half on the right has dark brown wings with a tan-orange band on the margins, and the female half on the left has black wings with blue on the margins.

He went on to explain that Diana butterflies are sexually dimorphic, meaning that the males and females are very different from each other. The males have tan-orange wings, and the female's wings are black with blue on the margins. This collector he was telling me about had caught a specimen that was male on one half of its body and female on the other—an extreme oddity. (It turns out that the hitchhiker was speaking of Thomas J. Allen, who six years later, in 1997, authored a book entitled *Butterflies of West Virginia and Their Caterpillars*, published by the University of Pittsburgh Press. A photograph of that bilateral gynandromorph is on the back cover of the book.)

"A specimen like that is worth thousands of dollars," he commented.

"Do you sell the butterflies you catch?" I asked.

"I used to, but not so much anymore. I usually donate most of mine to the Buffalo Science Museum. In fact, these days I usually release most of the ones I catch."

I remembered that Diana is the Roman name for Artemis, the wild virgin huntress. She was not only goddess of the moon but also of the chase. She was fleet of foot, an expert archer and she frequented wild places armed with bow, arrows and a spear. She was wild, beautiful and untouchable—chaste and pure—as were the bevy of nymphs who followed her.

The story of Diana's encounter with Actaeon, a young sportsman, reveals her power and the ruthless intensity of her wild, untouchable nature. Actaeon was a mere mortal, but like the goddess, Diana, he loved to hunt. One day he was out hunting with his buddies and his pack of dogs. Around noon, that fateful hour when the sun reaches its zenith and begins its descent into darkness, the hunting party stopped in the shade of a tree to rest. As it turned out, Actaeon and his buddies were not the only ones hunting that morning.

Diana and her nymphs, after a long and exciting pursuit, had also halted their morning hunt and retired to a favorite secluded glade "deep in the recesses of the wood, where the cold crystal of a mossy pool rose to the flowery marge...The cool waters rippled so invitingly that the goddess and her attendants

[gleefully flung their short hunting vestments aside and plunged into the clear waters to] lave their heated limbs."[8]

About this same time, while his dogs and companions were resting, Acteaon wandered off into the forest, and fancying that he heard bursts of silvery laughter, he crept cautiously and peered through the underbrush. There in the cypress-lined pool he saw the goddess Diana and her nymphs bathing. He was awe-struck by their beauty. He could not take his eyes off the scene. When they saw him, the nymphs shrieked in terror and tried to cover Diana with their bodies, but the goddess stood well above them. Diana was taken completely off guard, and she was furious. She was inflamed with indignation. Ovid reports that "a color that tinges the clouds at sunset or dawn came over the countenance of Diana."[9]

Her clothes and weapons were out of reach, so she slowly reached into the pool, caught some water in the palm of her hand and flung it into Actaeon's face. She looked him right in the eye, pointed a rosy finger at him and shouted, "Now, you just go ahead and say you have seen the goddess, Diana, nude—*IF* you can!"

As soon as the glittering droplets of water touched him, he began to get horny, literally. Antlers sprouted from his head, and his neck and limbs began growing longer. His hands and feet turned into hooves. He fled, and as he bounded through the forest he marveled at his own speed until he stopped at a pool to drink. There he saw in the reflection that he had been turned into a stag—a young buck. When he returned to his resting dogs and companions, they didn't recognize him. They promptly pursued and killed him.

I asked my new companion what it was about butterflies that so attracted him. He went on to tell me about how when he was a youngster in western New York, his dad used to take him on fishing trips. Rather than fishing, he would always end up with his dad's landing net chasing butterflies. "Something about their color," he said dreamily, "and I been into butterflies ever since."

Now here he was, an adult, traveling hundreds of miles with little more than a soft silken net, following his dream, passionately pursuing these untamed, elusive fluttering bits of color. And he was here at this moment, seeking the queen of them all—Diana, the one named for the goddess of the chase, the archetype of pure passionate pursuit. As the hitchhiker and I drove, our conversation rolled rapidly along, from the more common swallowtails and fritillaries to the more esoteric skippers, heliconias and saturnid moths. He went on to tell about unusual butterflies that he had hunted in many locations around the country. As we talked, he was pleasantly surprised to realize that I also knew something about butterflies. We introduced ourselves. (I'll call him Fred.) When I told him that I was going to teach workshops about nature lore, he reached into his sack again and pulled out a plastic margarine container with holes in the lid. He opened it and said, "Here's some viceroy caterpillars I've been raising. They're almost ready to pupate but they need some more poplar leaves soon. Take 'em with you, and you can raise them for your class." (I did and they all pupated and emerged in the next two weeks.)

Soon we came to the fork in the road where I would need to turn north toward Elkins and he would head east into Virginia. I offered to take him to his butterfly hunting ground since it was only about twenty miles out of my way. He directed me to a farmhouse where I dropped him off.

He walked across the road and up the driveway to the farmhouse. The man of the house came to the door. I heard Fred's part of their conversation as I turned around to drive off. "Hi, how ya doing? Yeah I'm back again this year. Hunting butterflies again. I was wondering if I could stay here again. I got some money this time. I'd be glad to give you a few dollars."

They went into the house, and as I drove off I thought of the last story that Fred left me with.

"I had been raising some hickory horned devil caterpillars," he told me, "and they were getting really big, man. You've seen 'em haven't you?"

Another Roadside Attraction

I had seen them, and they made quite an impression. The hickory horned devil is the larva of the royal walnut moth. They are very large and noted for their weird, fearsome appearance. They are thick-bodied and bright green in color, with short fleshy legs and a cluster of curved, sinister-looking, orange and black horns behind the head.

"Well, these were just about ready to pupate. I had a half dozen of them in a big paper shopping bag. They were beauties, man. They were as big as hot dogs, and their horns were an inch long! I was on the city bus in Buffalo, and I got off to go to the burlesque show," he said. "I went inside, and I folded the top of the bag up and tucked it in the corner. I stayed about an hour and I spent forty bucks. [I didn't ask what he spent it on.] Well then I left the burlesque show, got back on the bus, and I don't know what I was thinking about, but I got all the way across town before I realized that I'd forgotten my caterpillars. I'd left 'em there at the burlesque show! I didn't have the nerve to go back for them, man. Can you imagine what somebody would think, opening that bag of caterpillars at the burlesque show?"

"Like some new kind of French ticklers?" I guessed.

"That's right!" he said with a preposterous laugh.

Next time he goes to a burlesque show to view scantily clad nymphs, I hope he doesn't encounter the real goddess, Diana. She might cause him to lose more than his caterpillars.

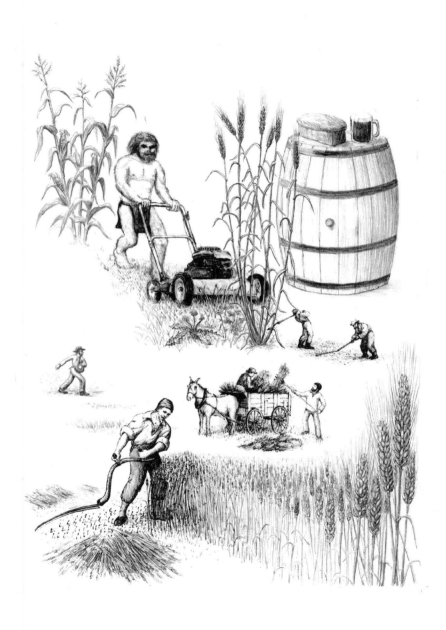

Keep On the Grass

Of Lawns, Weeds and Wheat Fields

As I look down from this tree, during this first flush of the growing season, it does seem like I am looking down on a tiny Eden—with the ponds, the creeks, the waterfall, the vibrant garden, the vineyard, the berry bushes and fruit orchard, complete with apple and fig trees—all surrounded by lush, forested hills. There is even an Adam and Eve who occasionally stroll around the neatly mowed lawns without so much as a fig leaf.

What, you say, "Mowed lawns? Mowed lawns and lawn mowers in paradise?" The word "Eden" naturally alludes to that long-lost primal paradise, that place of bliss and innocence where we could run naked and free and where we were in complete harmony with the environment. Trudging around pushing a lawn mower does not seem like a manifestation of environmental harmony.

Mowing the lawn is a simple, routine activity for most homeowners, but for me it is fraught with complexity and ambivalence. I know most of the plants that grow wild in my yard. Most of those plants are useful in some way; they are edible wild plants, healing medicinal herbs, interesting and beautiful wildflowers or botanical wonders—each miraculous in its own way. Why would I want to mow down living miracles—gifts from God? It seems so weird to just mow 'em down. Mowing the lawn seems just plain antithetical to who I am.

As dear to me as all my meadow grasses, dandelions, daisies, herbs and other precious wildflowers are, this is sort of a rough neighborhood. I don't mean the people; our neighbors are the finest. In our little Eden there is another problem.

Enter the serpent. There are indeed serpents in the garden—snakes in the grass—and some are seriously venomous vipers. We regularly find copperheads, and there are rattlesnakes in the area as well. Around here it is important to be able to see where you are putting your feet, especially on those warm summer nights.

So, we do mow the lawn. I tend to put it off as long as I can, but during the warm growing season it seems like every time I turn around the grass is eight inches tall and I've got to face it. I don the hearing protectors and eye shields, fire up the mower (it's a weed whip on wheels) and spend the morning roaring around the place, making all these *Sophie's Choice*-type decisions—steering around this clump of daisies or that lobelia, dodging that patch of red clover or sprig of St. Johns-wort. And finally, after I'm all through, my wife and I stand there on our front steps and admire the view, the smooth patches of turf and the neat, trim edges. Those mowed areas between the planted beds make Yanna's riotous garden look more under control and more manageable now. There is good visibility around sheds, woodpiles and other snaky places. The place looks so orderly, restful and pleasant. We inhale the delicious "new mown hay" aroma of freshly macerated plants, and we'll look at each other and say, "Oh, doesn't it look nice?"

Yes, it does look "nice," but the fact that I think this drives me crazy! I can't help but wonder that if I so abhor mowing all my beautiful plants and valuable herbs—these expressions of God's love—then why does it look so good to me after I've done it? Why does it feel so restful when everything is mowed down flat and smooth? Why is it so appealing? This is deep stuff and it was driving me crazy. How can I derive such pleasure and satisfaction from a flat, smooth, mowed, manicured monoculture? What is this all about?

Are we latent aristocrats? Do we have an ancient need to be lords of our medieval manor? Are we control freaks, trying to get control of nature? Does this give us the illusion that we are finally in control?

Or could it be some ancient genetic memory that goes back to the time of our ancient ancestors living on the savannas of Africa, when the only time we could feel safe from predators was when the

grass was short and we could see all around us? Could it be that this "lawnophilia," this love of lawns, is an ancient craving deep in our genes?

I had to get to the bottom of this, so I started researching lawns. Through the Internet and interlibrary loan, I found anthropology books on lawns, books on lawn history and even psychological theses and spiritual treatises on lawns. There is certainly more than one way to look at a lawn.

I was astounded to learn that the lawn we know—the middle-class American lawn—has a date and place of birth. It was born in Toledo, Ohio, in 1870!

It's not that there were no lawns before then. There were patches of turf in royal pleasure gardens in ancient China and Persia. In Europe, really wealthy people had manors and estates with large lawns. They mowed with herds of sheep or gangs of scythe-wielding serfs. A large lawn was (and maybe it still is) an ostentatious sign of wealth, because anyone who had that much land and didn't do anything useful with it had to be filthy rich.

The common people didn't have lawns. In talking to some of my rural neighbors in Western North Carolina, I learned that as recently as forty or fifty years ago, nobody had lawns. The yard around a house was kept bare and swept clean. In fact, if a little bit of grass came up in their yard, conscientious homeowners would use a hoe and chop that sprig of grass right out of there. People regularly swept the bare dirt in their yards with yard brooms made out of slender flexible branches of trees and shrubs or stiff grasses (like broom sedge, *Andropogon sp.*). In parts of the Deep South, yard brooms were made out of a shrub in the holly family known as Gallberry (*Ilex glabra*). They were often made by itinerant broom makers who would camp out in the bush, tie a batch of brooms and then travel from town to town selling them. One broom seller's street cry went like this:

> *Gallberry brooms! Gallberry brooms!*
> *Keep your front yard as clean as your upstairs rooms.*

In many third-world countries today, people's yards are bare, well-swept earth. In Europe and other parts of the world today,

people do have space around their houses and sometimes even lawns, but their yards are fenced, hedged or walled in.

The real all-American "everyman's" lawn needed two things to exist—it needed the lawn mower and the suburbs. The lawn mower was invented in England in 1830 by Edward Beard Budding, who worked in a carpet factory and designed the lawn mower on the same principle as carpet-trimming machines.

The suburbs (or at least the concept of suburban developments) were invented in the 1870s by a real estate developer named Frank J. Scott, who started subdividing land around Toledo into small lots, building homes on them and surrounding them with lawns. Scott is considered to be the first tract housing developer.

Frank Scott was an all-American man, and he had strong ideas about the "mean-spirited" confinement of the European walled-in yard. "It is unchristian to hedge from others the beauties of nature which it has been our good fortune to secure," he wrote in his 1870 work *The Art of Beautifying Suburban Home Grounds*. "Throwing the front grounds open together enriches all who take part in the exchange and makes no man poorer." This was America, the spacious land of opportunity where your home, no matter how humble, was your castle.

It was also the beginning of the industrial age. People were relocating to be near the cities for employment as cogs in the gears of the Industrial Revolution. They were no longer farmers. They could no longer afford to live in the open, spacious countryside, but Scott realized that when the workers came home, they needed to feel like they had come home to their castle, to their manor, to their estate. (How often do we see these words used in the names of suburban developments?) So he designed his suburban developments so that an average working stiff, even though he owned only a small parcel of land, could step out his front door and see a vast, undivided stretch of lawn that went on for many acres. It was as if it was all his estate, his manor. Of course he could see the neighbors' houses here and there, but those were like other cottages—perhaps the servants' quarters on the estate. It didn't matter that his house looked just like the others. It was as if it was all his, all neatly under control, as far as the eye could see. It might

not be his on the tax maps but the vista, the view, was his as far as the eye could see.

The suburban "estate" that Scott created in Toledo in 1870 has been replicated millions of times all over America, and it has become a symbol of our country. In the typical American suburb, it is difficult to see where one resident's lawn starts and the neighbor's ends. According to anthropologists, the undifferentiated front lawn is a uniquely American phenomenon—more American than apple pie. It fits the American psyche. As Americans, we want to put out a united front. We are "one nation, under God, [with one lawn,] indivisible, with liberty and justice for all [as long as you mow your lawn]."

If you want to test this, and you live in a suburban neighborhood with those undifferentiated front lawns, try something radical. (*Radical* refers to "root.") Scatter some wildflower seeds in your yard, and let them start growing up into a wildflower meadow or let the grass grow tall and turn into a natural prairie—you'll find out right away from your neighbors that even if you do hold the deed to the land, it is not really yours to do with as you like. Your front yard is for the community, for the neighborhood, for the nation—not for you. You can't just let your lawn grow wild. You can't do that here; this is the United *Estates* of America!

There are other ways of looking at the lawn, as well. In the book *A Man's Turf,* Warren Schultz[10] claims that the American lawn is really a guy thing. Certainly some women mow the lawn, but he says the lawn is really a man's turf.

We men psychically are not very different from our caveman, tribal, warrior ancestors. Even a modern man has a deep need to be in touch with his warrior-hero roots. He still needs to forge into the wilderness. He needs to hunt, to battle and to wrest sustenance for his family from the wilderness. He needs to seize the day, seize the world and take control...but of course this is the twenty-first century, and neither life nor the wilderness is like that anymore. The customer is always right and the boss is, too. Our modern office warrior has to be careful not to offend his co-workers, and when he gets home, he has to manifest the diplomacy it takes to get along in a modern household. So after a week of constant deadening,

demeaning, obsequious placation and wheedling platitude, all our suburban warrior wants to do on Saturday morning is burst forth from his bondage, charge out into that unfettered backyard greenery and take control of his world. (*Roar!*) For hours at a time he will immerse himself in the howl of the engine and a cloud of toxic hydrocarbons—insulated, isolated, immune and unstoppable—the indisputable master of his domain, mowing down everything in his path. They don't call it power equipment for nothing. She can nurture the flower gardens, but the lawn is his turf!

There are also the deep, spiritual, mythic, archetypal aspects of this lawn care ritual. One of the best ways to mow a lawn, particularly if is irregularly shaped, is to start mowing around the perimeter, and each time you come around you make a concentrically smaller circle. As you continue mowing, your circle keeps getting smaller and smaller until eventually you finish right in the center.

In this process, what you are inscribing there is the Great Spiral, the metaphor for all growth and life. Inside the chromosomes in every cell in our body is that double helix (those two intertwined spirals). These microscopic spirals are what make us who we are. Our life is like that, too. There are many cycles in our lives, but of course, every time we come around, a little more of our life has been lived—a little more of the lawn has been mowed. Things are different, we grow and change, we spiral in and we spiral out. The Great Circle of our life is really a spiral. Trees, stalks and vines grow in spirals. Pine cones, flowers, seed heads and seashells are arranged in spirals. And there are whirlwinds, hurricanes, tornadoes and typhoons, whirlpools and even the water flowing down your kitchen sink is a spiral. Spirals are everywhere. We think of the orbit of the earth as a circle, but it's really a spiral because our solar system is part of galaxy that's hurtling through space as part of an ever-expanding universe. So next time the tranquility of your summer Saturday morning is shattered by the roar of mowers, just sit back and think of the deep spiritual, metaphorical and anthropological implications of it all!

There was an interesting Judeo-Christian perspective that went around on the Internet recently. Imagine the conversation the Creator might have had with St. Francis about these lawns...

Keep On the Grass

"Frank, you know all about gardens and nature. What in the world is going on down there in North America in the Midwest and all around the edges of those towns? What happened to the dandelion, thistles, nettles, violets, brambles and other plants I started years ago? I had a perfect no-maintenance garden plan down there, you know, those plants grow in any type of soil, they withstand drought and multiply with abandon. Nectar from their blossoms attracts butterflies and honeybees, and their seeds feed the birds. I expected to see a vast garden of colors by now. But all I see is little green rectangles. What's going on down there Frank?"

"It's the tribe that settled there, Lord."

"Tribe?"

"Yes, Lord. You've heard of the Canaanites, Hittites and the Israelites. Well, these are the Suburbanites. Yes, they started calling your flowers weeds, and they go to a great extent to kill them off and then replace them with grass."

"Grass? Why grass? It's boring, it's not colorful, it doesn't attract butterflies or birds or bees—only grubs and sod worms. It's temperamental with temperatures. Do those Suburbanites really like that grass growing there?"

"Apparently so, Lord. They go to great pains to grow it and keep it green. They begin each spring by fertilizing the grass and poisoning any other plant that sprouts upon the lawn."

"Oh, these Suburbanites must really like the spring rains and the cool weather that we provide. They must really like that, because it makes the grass grow fast. That must make them happy, right?"

"Well, not exactly, Lord. As soon as it grows a little, they cut it, sometimes twice a week."

"They cut it? Oh, do they feed animals with it and bale it for hay?"

"Well, not exactly Lord. They rake it up and put it in plastic bags."

"They bag it? Why is that? Is it a cash crop? Do they sell it?"

"Well, no sir, just the opposite; they, uh, they pay to throw it away."

"Now, let me get this straight. They fertilize it so it will grow, then when it grows they cut it off and they pay to throw it away?"

"That's right, Lord."

"Well, they must really appreciate it when we turn the heat up in the summer, right? When we cut back the rain, it gets hot and dry. That slows the growth of the grass, and that saves them a lot of work. They must like that."

"Well, you aren't going to believe this, Lord. When the grass stops growing so fast, they drag out hoses and they pay more money to water it so they can continue to mow it and pay to get rid of it."

"Oh, nonsense. Well, I can see that at least they kept some of the trees. That was a stroke of genius, if I do say so myself. Don't you love those trees? The trees grow leaves in the spring and provide beauty and shade in the summer, and in autumn they turn bright colors and the leaves fall to the ground to form a natural blanket to keep the moisture in the soil and protect the seeds and the bushes. Plus, they rot and it makes compost to enrich the soil. It's all a beautiful, natural circle of life, isn't it?"

"You better sit down, Lord; the Suburbanites have drawn a new circle. As soon as the leaves fall, they rake 'em up and then they pay to have them hauled away."

"NO! What do they do to protect the shrubbery and the roots and the tender flower seeds?"

"Well, you see, Lord, after throwing away your leaves, they go out and they buy this stuff called mulch and then they haul it home and spread it in the place of leaves."

"Mulch? Where do they get the mulch?"

"Well, you see, they cut down trees and grind them up, Lord, and…"

"That's enough, Frank! I don't think I want to think about this anymore. St. Catherine, you're in charge of arts and entertainment. Do you have a movie tonight?"

Keep On the Grass

"Dumb and Dumber, Lord. It's a movie about…"
"Never mind, I just heard the whole story!"

Even though people have been mowing their lawns for hardly
more than one hundred years, they have been cutting grass for a lot
longer—and I don't mean making hay. The most important grasses
that we humans have been cutting are the grains—the cereal crops.
Almost all grain crops are really just big seeded grasses. Wheat, rye,
oats, millet, barley, corn, rice and spelt are all in the grass family.
(Buckwheat, amaranth and quinoa are not.) We have been cutting
and harvesting them since the dawn of civilization.

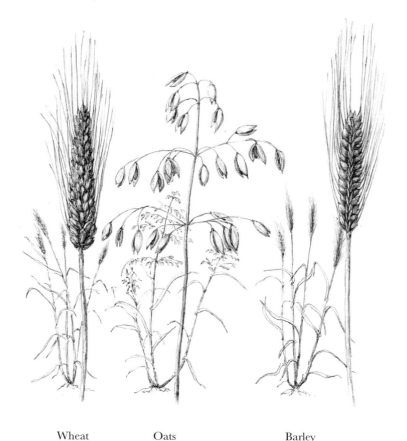

Wheat Oats Barley
Our civilization is dependent on grain.

It is really these grasses that spawned civilization. When people learned to harvest the seeds from these large-headed grasses—the cereal grains—they had a food commodity that they could store. With long-term food storage they could reduce their hunting, gathering, herding and other facets of their nomadic lifestyles.

Once people stopped being nomadic, life changed dramatically. Since they weren't constantly moving around in search of wild foods, game and pasture, possessions were no longer a liability—possessions became an asset. People started collecting stuff, and we have been doing it ever since. The concept of land ownership (real estate) developed because when you have got a crop of grain coming up on a piece of ground, the ownership of that ground becomes a lot more important than when you were chasing a rabbit across it. Once people acquired the means to store grain, accumulation of wealth became a goal. Once a society had wealth in the form of stored food, people had more time for arts, music, big government and organized religion. That's the way it's been ever since we learned to grow and harvest grain. Next time you drive around town, look around and remember—it's all because of grass.

In ancient times, people were profoundly aware of the miraculous life spirit embodied in the grain. In the British Isles, the ancient ones called the spirit of the grain "John Barleycorn." "Corn" is really the old European word for grain. Wheat, oats and rye were all called corn. When the New World grain, maize, was discovered, people began calling it corn and using the other names that we use now for their familiar Old World grains.

One of the oldest songs in the English language honors John Barleycorn. This old song celebrates not only the universal cycle of life and death but also all of the steps of the planting and harvest cycle. First, the earth is opened and John Barleycorn, the grain, is buried in the earth as if he is dead:

> *There was three men come from the west, their fortunes for to try.*
> *And these three men made a solemn vow, John Barleycorn*
> *must die.*

Keep On the Grass

They ploughed, they sowed, they harrowed him in.
Threw clods upon his head,
And these three men made a solemn vow, John Barleycorn was
dead.

But of course it is death that gives us life. When the rains come, the grain bursts forth with new life. It sprouts up through the earth and begins to grow. As summer comes on, the grain head swells, turning a pale yellow. It grows a "beard" of long seed hairs and soon becomes mature and ready for harvest:

They let him lie for a very long time and the rains from heaven
did fall
And little Sir John sprung up his head and so amazed them all
They let him stand 'til midsummer 'til he grew both pale and
wan
And little Sir John grew a long sharp beard and so became a
man.

Then the harvesters would mow the grain with scythes and tie bunches of the stalks together in bundles called sheaves.

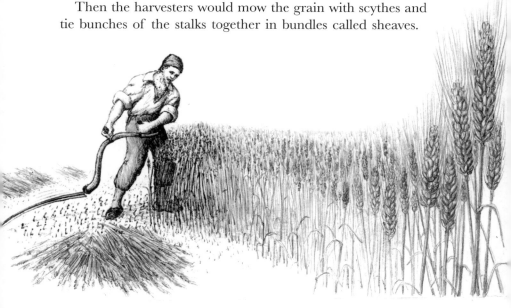

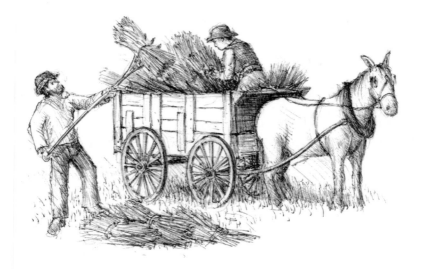

Using pitchforks they would load the sheaves in a wagon and pile them in the barn in a big stack or pile called a mow (rhymes with cow) until it was completely dry:

> *They hired men with scythes so sharp to cut him at the knee*
> *They rolled him, tied him 'bout the waist and used him*
> *barbarously*
> *They hired men with sharp pitchforks to pierce him to the heart*
> *And the loader he treated him worse than that for he bound him*
> *to a cart*
> *They wheeled him around and around that field 'til he came*
> *unto a barn*
> *And there they made a solemn mow of poor John Barleycorn*

Threshing is the process of separating the dry kernels of grain from the chaff. This was done by beating the head of grain with a flail. Flails were made from a short hardwood stick attached loosely by a leather thong to a longer pole. The heads of grain were beaten and flailed until the grain was freed from the chaff. Then it was winnowed by tossing it into the air on a breezy day to blow the lighter chaff away. The grain could then be ground into flour to make bread:

Keep On the Grass

They hired men with crab tree sticks to beat him skin from
 bones
And the miller he treated him worse than that
For he ground him between two stones.

The grain was also sprouted to make the malt for brewing. When a seed sprouts, the starches in the grain turn to sugars, and the other nutrients in the grain peak. Fermentation produces enough alcohol to preserve these nutrients. Brew was more than an inebriant—it was sustenance, and, of course, bread still is the staff of life:

They wheeled him here and they wheeled him there
And they used him worse than that
They wheeled him to the brewer who bunged him in a vat
Of all the things they did to him, this was the worst of all
A big man poured him down his throat and pissed him against
 the wall.

No matter what we do to John Barleycorn—bury him, cut him, beat him and grind him or piss him against the wall—we always save those seeds, because it is John Barleycorn who sustains us all.

Over the centuries, our relationship with John Barleycorn has grown in many ways since we humans first started gathering those plump grass seeds in the wilds of Europe, Asia and the Fertile

Crescent and the tiny cobs of wild teosinte, the ancestor of maize, in the Mexican highlands. Now it appears that it is John Barleycorn who now has control of us. Consider the millions of human lives around the world that are dedicated to nurturing John Barleycorn and the millions of acres that are protected and set aside for him alone. Huge chemical industries have evolved to fertilize John. We will poison our land with herbicides and pesticides and sometimes our fellow citizens, and even our own children (when they ingest traces of these pesticides), become casualties in our attempts to conquer the pests that would interfere with the growth of the almighty John Barleycorn. Who is in control? Have we cultivated John Barleycorn? Or has John Barleycorn cultivated us?

> *They worked their will on Barleycorn, but he lives to tell the tale*
> *Now they pour him out of an old brown jug and they call him*
> *home brewed ale.*
> *So here's to Sir John in a nut brown loaf and to good strong ale*
> *in a glass*
> *Little Sir John's still here today, proved the stronger man at last,*
> *For the huntsman, he can't hunt the fox, nor loudly blow his horn*
> *And the tinker can't mend kettles or pots without*
> *John Barleycorn.*

Long live John Barleycorn and long live us all!

CHAPTER 11

Way Down Yonder

Epiphany in the Pawpaw Patch

One sunny September day I was at an environmental center in northern Indiana. I was leading a nature walk with a nice group of folks. We found ourselves down by the lake in a grove of small trees. The trees had large, soft green leaves; the tip of each leaf tapered to a long, pointed drip tip that is characteristic of tropical rain forest plants. We were at the northern edge of the range of a tropical family of plants—the family known as *Annonaceae*—the custard apple family. In Mexico and Central America I had sampled sumptuous exotic fruits from that family—fruits with exotic flavors and colorful names like the guanabana and the cherimoya. On the Caribbean Islands I had relished the sour sop and the bullock's heart. On St. John we learned to listen for the excited raspy calls of the bananaquit birds in the scrub areas announcing ripe sugar apples.

Well, right there on this cool autumn day in Noble County, Indiana, we were about to get a taste of the tropics. How does the old folk song go?

Guanabana

Cherimoya

Where oh where is sweet little Sally?
Where oh where is sweet sister Sally?
Where oh where was Ranger Doug's weeds and woodslore
 walk?
Yes, we were indeed…

Way down yonder in the pawpaw patch.
Picking up pawpaws, put'n 'em in our pockets
Picking up pawpaws, put'n 'em in our pockets
Picking up pawpaws, put'n 'em in our pockets
Way down yonder in the pawpaw patch.

The reality was, however, we weren't exactly filling our pockets. We only found one pawpaw that day—just one perfectly ripe fruit to share with a group of about fifteen people.

The pawpaw is actually North America's largest native fruit. Neil Peterson, founder of the Pawpaw Foundation, told me that their largest pawpaw weighed in at one pound, fifteen ounces—just an ounce short of two pounds. But the pawpaw that we found that day was more typical. It was about four inches long and shaped like a short cucumber or a stubby banana. Sometimes they are called Indiana bananas. I really wanted everyone to be able to share in this marvelous fruit, so I used my poplar bark backpack as a cutting board and began carefully slicing. The flesh was a smooth, creamy yellow with large, glistening chocolate-brown seeds. Soon I had the entire fruit sliced up, and I passed them out. One by one, each person took a piece. There was enough for everyone. We each ate our slice, and the flavor was awesome! We were transported by sharing the succulent sweetness and the creamy sensuality— the perfect ripeness. It was mind altering.

The pawpaw is North America's largest native fruit.

Way Down Yonder

Then a strange thing began to happen. I began to feel like a minister who had just handed out communion. I started hearing voices. My head became filled with words, words I heard in church growing up. "Take, eat, this is my body which is given for you: do this in remembrance of me." These words are from Luke 22:19. They are Christ's words, spoken at the last supper as he broke the bread, but there in this Indiana banana patch, it was coming on strong and it all seemed so clear. Then more words: "Whosoever believes in this shall not perish and they will have everlasting life—because they will know they are part of the Whole, the One, God's creation, that Great Mystery and as a part of that Eternal Cycle, we will not perish and we will have everlasting life." I realized that we *are* everlasting life and that this is the message that the Creator—the Earth Mother—that God says to us every time we eat, breathe or partake of our sustenance. Every meal, every breath we take, every flower we smell, every berry we nibble is a sacrament—part of the body of the Creator, as are we. It is a sacred offering, and it all comes as the gift of Creation. Whew! Let me tell you; that was quite a pawpaw!

With its zebra stripes, its long swordlike tails and flash of red on the hind wings, the zebra swallowtail is in many ways our most elegant and distinctive butterfly. Though the adults sip nectar from a variety of flowers, these butterflies are rarely found far from pawpaw trees (*Asimina sp.*), which are the food plants of their larvae.

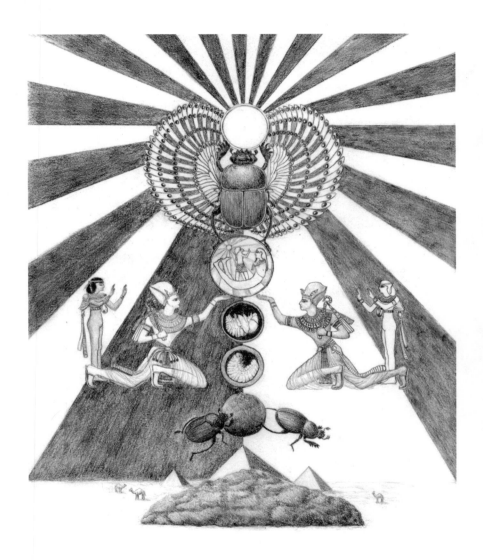

The Scarab and the Sacred Sphere

Of Dung Beetles and the Source of Life

W hat! Moving dog poop? Were my eyes fooling me? Yes, it was moving, all right—right there at the edge of the driveway. I was on my way to the mailbox but never mind that. I sat down right there and watched. It was definitely moving. A piece of this all-too-familiar canine "calling card" was rising up. Yep, levitating dog poop right before my very eyes! And underneath it was a handsome, shiny black beetle. The beetle had just cut off a chunk of feces. It had fashioned it into a perfectly round, symmetrical sphere about an inch in diameter, and now it was underneath heaving away. Its head was facing down, and its long hind legs reached up and grasped the sphere (reminiscent of the way ice tongs grip a block of ice). The ball of dung was almost twice its size. The beetle heaved with the front legs (like an upside down weight lifter), and the ball began to roll. It rolled half a turn and stopped, another heave and the ball rolled some more.

Inch by inch, across the miniature hills and dales it rolled its precious cargo, laboriously pushing it up each small incline. On the downward slopes, the beetle merely tried to hang on to keep the magic orb from rolling away.

A mere ball of poop has been transformed by this beetle into a sacred chamber of potential. Not only is it a nutrient bonanza, it is also a brood ball. Once an egg is deposited and the ball buried in the earth, it becomes a repository of valuable genetic material—that creature's unique contribution to diversity on the planet.

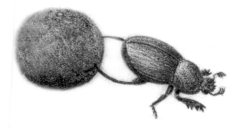

The beetle heaved with its front legs (like an upside down weight lifter), and the ball of dung began to roll.

Dung beetles lay relatively few eggs. Most insects lay dozens if not hundreds or even thousands of eggs, but dung beetles invest so much special care providing each of their eggs with food, shelter and protection that fewer eggs are needed to reproduce the species. In some species of dung beetle, the female may lay only one egg during the entire season. For an insect to lay so few eggs is extraordinary.

After the dung ball is interred in the earth and incubates for a number of days, the egg hatches into a tiny grublike larva. Safely underground, the larva feeds on the dung and eventually pupates. A few weeks later, a newly formed young adult beetle will emerge from the pupa, dig its way up to the surface of the soil and lift its hard elytra (the shell-like wing covers that fold over a beetle's back). It unfurls its membranous flight wings, and with a whirring buzz it flies away. It sallies forth on a pilgrimage, a mission, a quest—a journey into realms where other beasts refuse to tread: the fresh dung heaps left by larger animals.

For dung beetles, waste makes haste. "Before the sun becomes too hot, they are there in their hundreds, large and small, of every sort, shape and size, hastening to carve themselves a slice of the common cake," wrote the great nineteenth-century entomologist J. Henri Fabre as he described the frenzied activity of dung beetles in a French cow pasture more than a hundred years ago. There he observed as many as two hundred beetles of ten or fifteen species working on a single cow pie.

As you read this, millions of dung beetles are working day and night. They are practically everywhere, from our neighborhood door yards and lawns to farms, woodlands, pastures, prairies and deserts the world over, laboring with strength and determination, cleaning up dung and making a better world for us all.

The Scarab and the Sacred Sphere

Some species of dung beetles are generalists, able to use any pile of scat they can find. Others specialize in the droppings of either omnivores or herbivores. Still other dung beetles are super-specialists, dependant on the feces of a specific host, like the beetle that hangs out on the rear end of a sloth. This beetle patiently waits for its long-haired, torpid South American tree-hanger host to climb down from the forest canopy for its weekly defecation. Yes, you read correctly—only once a week. A sloth's digestion is as slow as its other movements. When it does poop, it doesn't just carelessly let it fly down from the treetops like monkeys do. Defecation for sloths is somewhat of a ceremonial event. When the time draws nigh, the sloth ever so slowly works its way down the tree, and once on the ground, it digs a hole in which to bury its waste. All the beetle has to do is jump into the hole at the right moment and it has everything it needs—food, shelter and a place to lay its eggs.

Other super-specialized rainforest dung beetles follow the howler monkeys. Early in the morning they fly to the rainforest treetops where the monkeys sleep. There they wait for the monkeys to awake and do their morning business. They collect the fresh monkey dung where it splatters on the large tropical leaves and roll it into balls. Inevitably, the beetle, ball and all, rolls out of the treetops and lands many feet below on the forest floor, the dung ball flattening like a wad of Play-Doh putty on impact. There the beetle patiently re-forms its ball and rolls it off for burial.

Out on the African savanna, only a few minutes after an elephant drops one of its hourly, four-pound loads, the pile will be literally seething with the activity of thousands of beetles of several dozen species. They can completely disperse the pile in a few hours. The largest dung beetles in the world are elephant dung rollers. These three-inch monsters charge across the savannas with brood balls the size of croquet balls. Sometimes they bury them eight feet deep.

In the African savannas, biologists have estimated that every year dung beetles bury half a ton of manure per acre. Along with cleaning up all that manure, the soil is aerated and fertilized with a huge amount of nitrogen, ensuring the healthy growth of plant life, which in turn nourishes the vast herds of herbivores. In fact, it is believed that without dung beetles, the African savannas and many

other environments throughout the world could not have evolved to support the vast herds of animals that now inhabit them.

Australia is a modern-day example. Australia has a number of native dung beetles that evolved to take care of the small pellets left by kangaroos and other native mammals. However, when European settlers moved in with their herds of cattle and other livestock, the small native beetles were not able to deal with these animals' enormous outputs of manure. A single cow can completely blanket a tenth of an acre with manure annually. In dry areas of Australia, the pats were lasting for several years, and they were so durable that ranchers were using them to prop up irrigation pipes. The dread native bush flies, which breed in excrement, increased to such a level that by the late 1960s they spawned what became known as the "Australian salute"—the constant swipe of the hand across the face to brush away the flies.

From 1970 and on into the '80s, the Australian government introduced fifty species of dung beetles from Africa and Europe. By now, thirty-two of them have become established—at least one, and sometimes as many as seven, exotic species of dung beetle now inhabit almost every pasture in Australia. Pastures that were once covered with a thick crust of manure are now lush and green again, and in some areas the beetles have reduced the fly populations by 90 percent.

Closer to home, during this same period, fifteen new dung beetles were introduced to Georgia and Texas. Estimates are that dung beetles could save the United States up to $2 billion a year by reclaiming pastures, recycling nitrogen and reducing fly populations.

Not all dung beetles are rollers (i.e., those that form a dung ball and roll it away). There are the tunnelers that bore down into the soil, making nesting chambers directly under the pat and dragging dung down with them; and there are the dwellers, those that simply move into the dung where it lies, chow down heartily and lay their eggs there.

Back at my driveway here in North Carolina I learned about another kind of dung beetle. When I watched that beetle bury its ball, I marked the place with a twig, wondering about how the

beetle might develop and when it might emerge. After a few days, however, my curiosity got the best of me. I returned to the spot and carefully unearthed the ball, rolled it out on the ground and broke it open. I wanted to see the egg. You can imagine my surprise, however, when I found not an egg but a tiny beetle tunneling through the ball. Was this the new baby beetle? No way. Young beetles do not look like adult beetles; they look like grubs or larvae. Any fully formed beetle, whether it's the size of a pinhead or a golf ball, is a full-grown adult. This was an entirely different species of dung beetle with a different lifestyle. This little rascal was a klepto-parasitic dung beetle that makes its living by moving in and stealing the dung that another beetle has collected.

Thousands of years before Christ, the ancient Egyptians watched dung beetles rolling their loads across the desert sands. They linked what they saw with their observations of the heavens. They believed that a celestial dung beetle known as Kepeherer, the sacred scarab, was responsible for bearing the solar orb on its daily journey across the sky. Every evening in the West the great celestial sphere is buried, just like the scarab's ball of dung, and just like the newborn scarab beetle that rises out of the sands, every morning on the eastern horizon the brilliant ball of the sun rises out of the earth and brings a new dawn to the day and new life to the world.

If something as lowly as the humble dung beetle, as well as something as glorious as the sun, can be reborn after it was dead and buried, could it be that humans might also experience rebirth and life after death?

To investigate this eternal question, the ancient Egyptians observed the scarab. They saw the various stages of the beetle's life history. They watched the wormlike larva 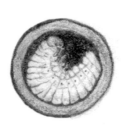 living and growing, neatly encapsulated within its own sphere of existence, squirming about, eating constantly and carving itself a cozy little niche inside its own personal ball of dung. "This is not unlike the human condition," Egyptian theologians might have surmised. When the larva has eaten almost all of the ball,

and nothing but a thin wall separates it from the surrounding earthly outside world, it slows down, stops eating and pupates. All external movement stops while the pupa drops into a deep, transformative sleep. The early Egyptians contemplated the quiescent pupa lying in its underground chamber, bound tightly in its pupal wrap. After a time, the pupal skin splits open, and this once-inert creature crawls forth, metamorphosing into a glistening adult that pushes up out of the earth.

Bearing jagged protrusions on its head and serrations on the front legs that look like the rays of the rising sun, the gleaming new being unfurls its sparkling, diaphanous wings and soars, buzzing triumphantly off into the heavens.

"Could this be a metaphor for us humans?" the Egyptian priests might have wondered. Whatever their conclusions, the fabulously wealthy and powerful Egyptian royalty were taking no chances. They devoted most of their lives and fortunes, as well as those of thousands of their slaves and subjects, to building and preparing proper pupal chambers for their own metamorphoses. The royal crypts of the Egyptian rulers were provisioned with everything from golden, bejeweled coffins to hieroglyphic prayer books, chariots, maps and hand-painted murals of the underworld. The body of the deceased ruler was preserved by an elaborate embalming process using herbs, spices, oils, resins and gums. Often the heart was removed from the body and replaced with a stone carving of a scarab beetle. The body was wrapped in strips of linen to form a mummy, and the royal coffin was covered by an ornate sarcophagus.

Some claim that the Great Pyramids were an attempt by the pharaohs to conceal their remains and protect the accompanying treasures from grave robbers. I still can't help but think about that little klepto-parasitic dung beetle quietly working away there in the soil beside my driveway, plundering the work of others in the same way the grave robbers plundered tombs in Egypt many centuries ago. Only a few Egyptian tombs survived undisturbed into the modern era, and now much of their wealth has been

removed and is in the possession of the European museums. Are they institutional klepto-parasites?

Entomologist Yves Cambefort (one of the editors of *Dung Beetle Ecology*) speculates that the tightly bound Egyptian mummy is actually an attempt by the ancients to replicate the pupa of the sacred dung beetle. He suggests that the Great Pyramids, in all of their glory, just might represent stylized camel or cattle plops!

Amid this lively flurry of cross-cultural interpretation, theory and speculation about the artifacts and belief systems of ancient Egyptians, we must not ignore or discount the deep intrinsic wisdom of a culture whose spirituality honors the burying of manure in the ground as a source of rebirth and new life.

The Great Pyramids, in all their glory, just might represent stylized camel or cattle plops!

CHAPTER 13

Of Ginseng, Golden Apples and the Rainbow Fish

Ancient Tales and Mountain Treasures

I f you want to go 'seng hunting, you come up this fall, and we'll run yo' little legs off!"

That sounded like both a challenge and an invitation to go on a ginseng hunt. The offer came from Ted and Leonard Hicks when I was visiting their family homestead high on Beech Mountain in Western North Carolina. I had come there, like so many others, to listen to their dad tell stories. Their father, Ray Hicks, was a national treasure, known for his incredible repertoire of old-time Appalachian stories.

I had long enjoyed Ray's storytelling. He was a master of the Jack tales—stories about the naïve, but resourceful, archetypal trickster character named Jack. Many of us first heard about Jack in the story "Jack and the Beanstalk." As it turns out, the beanstalk story is only one of hundreds of these stories that were brought over from Europe by early settlers, and they were kept alive and relatively intact by those who settled the isolated hills and hollers of the Appalachian backcountry. Ray knew dozens of these wild, elaborate and fanciful tales and was more than willing to share them with anyone who came his way.

Ray was getting too old to roam the hills like he used to, so the opportunity to go ginseng hunting with his sons was too good to pass up. Ginseng is a valuable medicinal herb found in the deep shady hollows and hillsides of the Appalachian Mountains. So one morning in early October, when I knew most of the ginseng berries would be ripe and the leaves would be turning that distinctive shade of yellow, I showed up at the Hicks homestead. There I

met Leonard at the top of the driveway, where he informed me that both he and Ted had gotten jobs and they had to go to work that morning.

Since I was there already, I went down to the house to say hello to Ray and Rosa. I knocked on the door and heard Ray say, "Come in."

I could tell that he sort of recognized me from previous visits, but it seemed like he was having trouble placing me. His wife, Rosa, hollering in from the kitchen, reminded him I was the "'possum man" and that I had been there a few times over the years.

I don't know about how it is where you live, but among these folks mentioning 'possums is a great icebreaker. And indeed Ray warmed quickly to the subject. He started talking…and he pretty much kept on talking till later that afternoon when I stood up and said I had to leave. He started in about the mating habits of 'possums, how the male's organ was forked and how when they mate, he puts it in "her nose holes" and how these little "jelly-like things form in there, and she just snorts 'em into her pouch." He also told me about how "them little 'uns latch right onto her tits and don't let go until they're 'bout grown." I had heard much of this kind of discussion before (and I had surveyed the scientific literature about 'possums). I knew that he was right about the male 'possum's bifurcated penis and about the little 'possums' adherence to the mother's nipples. As for his account of the mating habits and sexual practices, there has been little scientific documentation confirming what he described, but what a tale! I just listened and took it all in. (For more on possum sexuality, lore and lifestyle, see *Wildwoods Wisdom*.)

This is what I had come for. As much as I enjoyed his old stories about Jack, I really loved to hear his and Rosa's observations and interpretations about the natural world. They told me that screech owls will latch onto chickens and suck their blood. They will get up under the wing or on the chicken's back. Rosa said she saw it happen to one of their chickens when she was a girl. Her daddy heard a commotion out at the chicken coop and found the rooster in distress. When he brought it back to the house, there was what looked like a lump on its back. The lump, they soon realized, was the screech owl. That rooster never would go into the coop at

night after that experience. It would roost in the house right on the woodpile next to the fireplace.

Ray told a story about being out in the woods gathering white haw bark and other herbs. While he was gathering, he heard these two fellows talking loudly, discussing whether to run him off or not. It was just before dark, and he figured he'd better get out of there. They followed him out of the woods, talking and threatening all the way. When he got out of the woods and onto the road, he looked back just in time to see one of them fly out of the woods on dark wings, make one quick swoop over the field and disappear into the dark forest. It had been two hoot owls hollering at him.

He spoke about three kinds of wild cats (in order of size): the bobcat, catamount and panther ("what they call a cougar or a mountain lion anymore"). Ray said that he was followed by a panther one time. He filled his shirttail with rocks and kept throwing them at it, but it was in the trees, following him. Someone had advised him to head into an open field in this circumstance, so this is what he did. When he got out into the open field, the cat refused to follow. It stood at the edge of the forest, screamed three times like a woman and disappeared. Ray was glad that he remembered that advice.

We talked about ginseng (more on ginseng in *Wildwoods Wisdom*) and about how ginseng hunting gets in your blood. He was saying that when you're walking through the woods, you can tell the places where ginseng is likely to grow—in the richer coves often near chestnut stumps, grapevines or black walnut trees.

"Thar's a little fearn..." Ray was saying, speaking in his

"Ginseng hunting gets in your blood."

rich Appalachian dialect, full of archaic expressions and word twists. At first I didn't understand what he was trying to tell me about. Then I realized he was talking about a fern, pronouncing the word like "fee'-ern."

"Thar's a little fearn I look for," he went on to say. "If'n you find that fearn, you'll find 'seng (if somebody ain't got there first and dug it). See, this here fearn, 'hit's all hooked up with ginseng. Thar's a fungus hooked up thar 'tween their roots."

I realized he was talking about rattlesnake or grape fern (*Botrychium sp.*). This little fern grows in the same rich hollows as ginseng, and many mountain folks call it "'seng sign" or "'seng pointer" because it's commonly known to grow in association with ginseng.

When I got home, I looked up the word "fern" in my dictionary, and it said that our word "fern" comes from the Anglo-Saxon "fearn." So here was this backwoods mountaineer, a vestige of another era, living without a phone or indoor plumbing, speaking an ancient, archaic dialect. Yet he was discussing subterranean microscopic mycorrhizal associations between plants—something that is only just beginning to be understood by modern scientists.

"'Seng sign" is a little fern that points out ginseng.

Jack in Two Worlds is the title of a recent book about the Jack tales and their tellers. I was amazed at how apt that title is in relation to what I had just heard.

On a previous visit I had asked Ray about dung beetles, and he told me he called them "tumble-turds" because of their habit of rolling balls of manure. He had seen them struggling to roll their balls up the hill and had tried to help them with their load, but "they'd always get scared

and sull up" (play 'possum), he lamented. I like to visualize Ray as this sweet-natured, open-hearted "Jack-like" mountain lad who was willing to stop along the way to help a dung beetle roll its heavy load.

He said there was a Jack tale about dung beetles that his granddaddy used to tell, but it was "too rough for Richard Chase to put in them books" (the classic *Jack Tales* and *Grandfather Tales* by Richard Chase). He said he'd "study on it" for me and see if he could remember any of it.

When I asked about it this visit, parts of two versions of the story came out. One version of the story came from his granddaddy and another from a neighbor. The best I can distill from what he told me goes something like this:

It seemed like Jack was in a rivalry for the princess ("the king's girl"). His rival offered him a whole bag of gold if Jack would agree not to say anything for three days. He agreed.

Before long, a set of circumstances involving treachery and deceit ensued, and he was hauled into court and accused of various crimes. Since he could not speak for himself, he was thrown into the lions' den "with a mamma lion and her two cubs—and the lions were hungry." Fortunately, however, Jack had a way with animals, and somehow he made peace with the lions.

Meanwhile, back at the castle, the king's girl and the rival were in the bed together. The rival was indeed a fast mover!

However, Jack had a few moves of his own, even though he was trapped in the lions' den. He called forth some animal allies—the mouse and the tumble-turd beetle—and he sent them on a mission. He sent the mouse to tickle his rival's "nose holes" to make him sneeze furiously and to make his nose run uncontrollably. The tumble-turd beetle was sent to roll a ball of manure up between them. The other version says the beetle rooted out a pile of manure from his rival's back end. Whatever the details, the result was that some serious shit was stirred up between them.

The princess was completely grossed out, and she promptly terminated the relationship; she threw the rival out of bed and went straight to the lions' den "to see if Jack was eat up or not."

Well, there was Jack, smiling up at her. He was in fine shape. He had the mamma lion tied up on a leash, and he had made pets of the two cubs. Last we heard, ol' Jack was still married to the king's girl. He's still got most of that bag of gold, and he's a' doin' well.

I had just heard the story of "Jack, the Tumble-turd and the Mouse," a tale full of preposterous absurdity and clear lessons, not only about drawbacks of allowing the lust for gold to supersede one's ability to defend oneself, but also about open-heartedness and forgiveness, where naïve and simple Jack joins forces with two lowly beasts and triumphs.

The most memorable story that Ray told me that day was "Jack and the Three Sillies." He told me that that story had come from "across the waters," and he had learned it from his daddy. Little did I imagine how this fanciful tale would intertwine with my life. In this story Jack is married, and he and his wife are destitute. The only thing they have of value is her cow. They decide that he would have to take that cow and sell it.

"If you're gonna sell my cow, Jack, be sure you get fifty guineas for it," his wife admonishes. (We're talking about coins here, not about guinea hens.)

He goes off down the road, leading the cow by a rope made of hickory bark. The cow wraps the rope around him, tangles him up, knocks him over and starts butting him with her horns—when down the road comes a man driving a pig. He offers to trade his pig for Jack's cow. Jack was tired of getting butted, so he said, "Believe I will."

They trade, and now he goes down the road with the pig. After a while, the pig tangles him up in the rope, just like the cow did, and the pig gets him down in the mud and starts rooting over him—when down the road comes a feller with a cat.

The guy tells him the cat would make a good mouser. Wouldn't he like to trade the cat for his pig? Tired of being rooted over, Jack says, "Believe I will," and he trades the pig for the cat. Now Jack has a cat. The cat sees a bird and tries to get loose to chase the bird. Jack holds onto the cat, and the cat scratches Jack all over. About then another fellow comes along and says, "I'll trade you this here rock for your cat. This rock would make a good door prop." Tired of being scratched, Jack says, "Believe I will."

Of Ginseng, Golden Apples and the Rainbow Fish

When Jack arrives home, all he has is the rock. His wife is totally disgusted. "A rock!" she yells. "All you have is a rock?"

"That's not just any ol' rock, darlin'. 'Hit's a door prop."

"My cow for a doorstop! Jack you're the biggest fool I ever met!" She throws the rock out into the yard. "I am leaving you, Jack, and I'm not coming back—that is, unless I can find three bigger fools than you." And down the road she goes.

The first person she meets is a miller who is looking into his millpond all upset and despairing because he sees the moon sunk in his millpond, and now "I won't know when to plant my crops," he laments, "because I plant by the moon!"

She shows him that the moon is still up in the sky and that is just a reflection in the pond. He is so relieved and delighted that he gives her ten guineas, which she tucks into her apron and continues down the road.

Next she comes upon an old man and an old woman. The woman is plowing a field with her husband hitched up to the plow. Jack's wife watches them moving laboriously down the field. When the old man gets to the end of the row at the edge of the field, he doesn't stop and turn around to plow the next row—he keeps on pulling that plow straight ahead until he is all tangled up in the bushes, brambles and briars at the edge of the field. The old woman says, "What's the matter with you, old man?"

He looks around and replies, "Thar ain't nothing the matter with *me*! Don't you know when to say, 'Whoa'?" The entire time they are arguing, there is a mule right there in their pasture that they didn't know how to hitch up. Jack's wife shows them how to hitch up the mule, and they are so pleased they give her fifteen guineas. She tucks that money into her apron, and down the road she goes.

Then she comes to a house and hears a hollering and a pounding noise coming from behind the house. "Wham—Ow! Wham—Ow! Wham—Ow!"

She peers around the back of the house and finds an old woman who has put a cloth over a man's head and is beating him on the head with a stick.

"What are you a' doin'?" Jack's wife asks.

The woman explains that she is fitting her husband for a shirt, and she has to beat on the cloth enough so that his head will come through to make the hole for the collar. "'Hit's just awful," she says. "I can only make him one shirt a year because it takes him so long to recover from the beating."

Jack's wife shows the woman how to cut a hole in the cloth using scissors or a knife. They are so pleased that they give her twenty-five guineas. She looks in her apron and realizes she now has her fifty guineas. She goes back home and tells Jack she met three bigger fools than he. "And last I heard," Ray concluded, "they're a' doin' well."

About then, Rosa called us to eat. We had some corn bread and beans along with some other groceries I had brought. After lunch I slipped away and headed toward home. It was a sparkling autumn afternoon. As I was driving down the mountain, I admired the beautiful, clear creek that flowed along beside the road. Then I spied some fine-looking golden apples on a tree in a thicket on the other side of the creek. This was clearly an untended "wild" tree, so I thought I'd get some.

I pulled over and took a bucket with me. I would have to jump the creek to get to them. As I got ready to jump across the creek, I looked down and right in front of me, in the water, there was a good-sized trout. When the trout saw me, it darted under the big tussock of grass that I was standing on. I got down on my hands and knees and rolled up my sleeves to feel for that trout to see if I could catch it. There was a cavity up under the bank. Grass fibers waved in the current and tickled my arm as I reached back into that hole. I probed deeper and deeper, until suddenly I felt it—that slick, soft, quivering silkiness—the trout was in there! It was teasing my fingertips, darting just out of my reach. I lay down on my belly so I could reach deeper. I was lying there—my face inches from the water—the sound of the flowing water was in my ears and my feet extended up the bank. My hand gave me a vivid image of the contour and layout of this dark, watery cavity. I could feel the fibrous grass roots, the rocks, the gnarled, knobby tree roots and oozy clay. I was reaching my whole arm deeper

Of Ginseng, Golden Apples and the Rainbow Fish

and deeper up under that grassy bank, lost in a probing, tactile reverie, when I heard a noise in the thicket above me. It was a dog—a well-groomed setter—that went into a confused point when it saw me, and right behind the dog was a well-groomed middle-aged woman walking briskly up the road. She peered down at me warily.

"Hi, how you doing?" I said. She did not answer me. She just called her dog and kept right on moving up the road.

I finally managed to grab the trout and pull it out. It was a magnificent fish—a nine-and-a-half-inch rainbow trout with a beautiful pink blush on its speckled flanks. I cleaned it right there on the spot. Then I went across to the apple tree and started harvesting. The apples were a golden yellow, crisp and sweet. I filled my bucket with them. So now I had a bucket of apples and a nice fish to top off the bucket.

I thought of old wandering Aengus in the poem by William Butler Yeats, who went out in the twilight, caught a trout and took it back to his cottage to cook. He laid the trout on the floor and blew the coals of his fire into flame...

When something rustled on the floor and called me by my name.
The trout had become a glimmering girl, with apple blossom in her hair.
She called my name and ran and faded in the lightening air...

As a fisherman and a traveler on this winding road of life's journey—this road of ups and downs—I thought about how we seek the delicate, fleeting floweriness of youth and beauty.

Though I am old with wandering through hilly lands and hollow lands,
I will find out where she has gone and kiss her lips and take her hands,
And we will walk through the long and dappled grass till time and times are done
And pluck the silver apples from the moon and the golden apples from the sun.

As I munched those sweet golden apples, I remembered the ancient Greek story of Atalanta, the fair, free and swift-footed maiden who was a follower of the goddess Artemis or Diana. Like her mentor, she avoided the company of men and devoted herself to the chase. But unlike Diana, she had a mortal form and a woman's heart. When her father bid her to marry, she replied, "I will be the prize of he who will beat me in a foot race; but death will be the penalty of all those who try and fail."

In spite of the terms, a few brave and lusty young men tried to outrun her, and their lifeless heads were displayed on the racing grounds to deter any other suitors. Hippomenes, who was a judge at one such race, thought at first that these foolish men risked too much—until he saw Atalanta lay aside her robe for the next race. As she darted forward, she was stunning. According to Ovid, "The breezes gave wings to her feet; her hair flew over her shoulders, and the gay fringe of her garters fluttered behind her. A rosy hue, like that which a crimson curtain casts on a marble wall, tinged the

whiteness of her skin."[11] Her competitors were outdistanced in the race and put to death without mercy.

Unable to contain himself any longer, Hippomenes stepped forward, saying, "I offer myself for the contest."

When Atalanta saw him, she was overwhelmed with tenderness. She hardly knew whether she wanted to conquer such a handsome youth as he. While she hesitated, the spectators grew impatient, and she knew that she must prepare for the contest.

Meanwhile, Hippomenes addressed a prayer to the goddess of love: "Help me Aphrodite, for thou hast impelled me. Foster the fire of love that thou hast kindled…" Aphrodite heard his prayer and gave him three golden apples that she picked from the golden tree in her temple garden.

Soon the race was on, and because Atalanta was so filled with pity, she hesitated and Hippomenes took the lead by one stride. Yet reclaiming her resolve, she was soon catching up to him, and "he felt the rapid and repeated gush of her warm breath behind his shoulder." That's when he dropped the first apple. She saw it roll, glittering, into the grass, yet onward she raced, beginning to overtake him. He dropped the second apple. She hesitated for a split second but continued overtaking him. When he released the third golden apple, she couldn't resist and she stooped to pick it up "swifter than a wren picks up a grain of millet."[12] Yet when she lifted her head, she saw Hippomenes cross the finish line.

> *She stood in mute despair; the prize was won.*
> *Now each walked slowly forward, both so tired,*
> *And both, alike, breathed hard, and stopt at times.*
> *When he turn'd round to her, she lowered her face*
> *Covered with blushes, and held out her hand,* [with]
> *The golden apple in it.*
> *He did take the apple, and the hand.*
> *"Both I detain," said he.*
> *"The other two* [apples] *I dedicate*
> *To the two Powers that soften virgin hearts,*
> *Eros and Aphrodite; and this one* [remaining apple]
> *To her who ratifies the nuptial vow."*[13]

Those apples kept calling to me on the way home, each one a call to adventure—a fortune in the offering, like the "ripples on the surface of life" that Joseph Campbell mentions "that reveal hidden springs as deep as the soul itself."

I kept seeing more apple trees as I continued on that winding road down the mountain. Some were in people's yards. Others, like the one I just stopped at, were clearly wild and untended. Some were in that uncertain middle ground.

As I got down into the edge of the town of Banner Elk, there was an apple tree dropping red apples right beside the road. I pulled over, hopped out of the truck and was picking apples up off the ground when I saw an elderly gentleman coming over to me saying something. At first I couldn't hear him well so I went closer, and he repeated, "If I'd wanted you to get those apples, I'd have called you."

"I'm sorry," I said. "I was just picking them up off the ground. I didn't think anybody wanted those apples. Some of them's practically in the road."

He nodded and said that some deer hunters he knew wanted them. "What's your name?" he asked.

I told him, and he said, "All right Doug, get you a half a dozen or so to eat and go on."

Feeling sulky and prideful, like I'd been admonished or scolded, I didn't pick up any of those apples. I just got in the truck and drove off. The only apple I took was the one apple I had been holding. I started munching it as I drove away. It was absolutely delicious. It was even better than the apples I had just gathered. It was one of the best-tasting apples I had ever eaten. Now I wished I had gotten the half a dozen that I had permission for.

Then in the small town of Linville, I saw another tree in a mowed municipal area. The ground around the tree was covered with fallen apples. As I pulled over, I saw another man with a bucketful walking back from the tree. At first, I thought I'd just drive on, since there was already somebody gathering these, but I stopped and asked him if he wanted to get any more. No, he said. He just wanted that one bucket. "Try that tree over there; those apples are even sweeter

than these," he said. Before long, we got to talking about apples, and the next thing I know he's helping me fill my bucket. Then I come to find out he lives right down the road from me. We were both some sixty to eighty miles from home. He'd even been to one of my shows in our local town of Rutherfordton.

I stopped one more time as I passed through the national forest, remembering that I had started the day with the intention to hunt ginseng. There were still a few hours of daylight left so I headed off into the woods. I worked my way up a creek, traveling across a rich, north-facing slope. I started to see grape ferns, those "fearns" that Ray had told me about, and before long, the distinctive yellowing leaves of ginseng caught my eye. There were about forty plants in this area. Because ginseng has a high price on its head and is being over-harvested in many areas, I was particularly judicious about my gathering from this patch. I harvested the leaves, since they contain much of the same tonic and adaptogenic properties as the root, and they were about to drop off anyway. I dug carefully beneath two of the larger plants and carefully removed the lower portions of the roots, while leaving next year's bud and the upper part of the rhizome with the auxiliary roots intact. If all went well, even though I had dug the roots, these plants would continue to grow. There were still a few berries on some of the plants. I picked these, carried them along with me and tucked them here and there beneath the forest duff as I traversed the slope.

On the way down out of the woods I came upon a clump of creamy-white mushrooms growing out of a decaying tulip poplar stump. These were the delicious and easy-to-recognize wild oyster mushrooms that command high prices in gourmet health food stores. This clump of mushrooms might have started many years ago as a microscopic spore floating on an air current. It might have even traveled around the world before it came to land on this dying tulip poplar. Its hairlike mycelia had been creeping through the fibers of the moist, dead wood for many months. Now they had fruited, and I was picking the fruits.

I thought about how a few years before, some scientists had collected Armellaria mushrooms (another species that lives on

wood) in different locations in a large section of forest that they were studying out west. When they did genetic testing on these specimens, they were astounded to find that they were genetically identical. Not only were they the same species, they were actually the same mushroom, connected over 2,200 acres or 3.4 square miles by a dense network of subterranean fungal roots called mycelia. When they assessed their findings, they realized that the largest living organism on earth might actually be a mushroom. They named it "the humongous fungus."

This book started in a blossoming tulip poplar tree in its prime, during the peak of the spring bloom. Now it was autumn, and this long-dead poplar—this tree of life—was still offering another gift before its return to the earth.

As I drove home, it occurred to me that the second half of the day had been a lot like an extension or a living-out of the first part of the day. In the morning, I had heard all those tales from Ray and Rosa about their various encounters with plants and animals. And I heard the adventures of Jack and his wife on their meandering mythic quests, encountering all those characters and creatures as they traveled along seeking their fortunes.

Of Ginseng, Golden Apples and the Rainbow Fish

I realized that I am like Jack and that we are all like Jack or his brothers or his wife. We are all traveling through the world, meeting strangers and seeking our "fortunes." The lesson of Jack is open-hearted, open-minded naïveté. He may be smart, creative and resourceful in some stories (and an exasperating simpleton in others), but his open-hearted way of meeting the world is what most often solves his problems and allows us to conclude that he is "a' doin' well." When we are open-hearted and childlike like Jack, the world opens to us. Even the Bible reminds us that "unless we receive the kingdom of God like a little child, we shall not enter therein" (Mark 10:15).

That day, like every day, I had set out seeking my fortune. And it was a day full of riches, not only from Ray and Rosa—their hospitality, stories and lore—but also from the strangers along the road and from the wild things I encountered: the mushrooms, the ginseng, the golden apples and the rainbow fish.

Those golden apples calling to me from the roadside slowing me on my homeward journey were like those apples tossed by Hippomenes in his race with Atalanta. These were the apples that slowed and distracted her on her race and allowed her to soften her heart and meet her destiny.

The strangers I encountered on this journey each embodied some kind of mythic lesson that I am still trying to figure out. Like what about that first woman and her dog? They caught me in a very compromising position—lying there on my belly embracing the earth mother, my feet literally above my head, my ears full of the sounds of her gurgling, singing waters, crying out to me, while I was feeling her, literally up to my armpit probing her damp, watery cavity, reaching ever deeper for that quiver of wildness, that throb of untamed nature hidden in her depths—whew! Sometimes you get yourself in a position where you just can't explain yourself, and you best not try.

My encounter with the second stranger (the man who didn't want me picking up his apples) was initially one of rejection and denial, but after I called myself by name, he then relented and offered them to me. These were the only apples that were

directly and freely given to me—and I haughtily refused them. I wanted the generosity on my terms, not his, and the fortune of six of the best apples I had ever eaten was lost to me. Yet I came away with an important lesson—that sometimes pride and shame (a lack of open-heartedness) can come between you and the best fruits.

And the third stranger I met under the apple tree showed me that in recognizing nature's bounty and by reaching out to another human, community can be found, even far away from home.

I think about naïve, simple Jack—how he left home to seek his fortune with a valuable cow and came home with nothing but a rock. He'd been butted, beaten, rooted, bruised, scratched and muddied. And now his wife had left him. She had to leave (as we all have to do at various times in our lives). She had to get out of there to take stock of her situation. She had to go out and explore the world on her own—and when she did, she found a fortune out there in the world (fifty guineas, anyway). When she saw how absurd the world can be, she realized that indeed she also had a fortune at home. When she arrived back home, open-hearted Jack was there waiting for her with open arms. The cabin door was wide open—propped open with that rock.

When I got home that evening, Yanna, Todd and I sampled the apples. We brewed some fresh ginseng tea and sautéed the oyster mushrooms with ramps. We ate the mushroom and marveled at the idea that we might be eating a chunk of the largest living thing in the world. And whatever its size, like all of our sustenance, like the pawpaw, it is still a sacrament—a sacred gift of Creation. The flesh of the fish with the rainbow on its flanks was pink and succulent. For dessert we made apple sauce from those mountain apples and sweetened it with tulip poplar honey from our own beehives. At bedtime I told Todd the story of "Jack and the Three Sillies." He was quietly amused, rolling his eyes a number of times with the ridiculousness of it all. And as far as I can tell…we're a' doin' well.

Notes

CHAPTER 1:
1. Maurice Maeterlinck, *The Life of the Bee*, 25. Maurice Maeterlinck was a twentieth-century Belgian poet, playwright and essayist.

CHAPTER 4:
2. Jerry Hayes, "The Classroom," 107.
3. Bernd Heinrich, *Bumblebee Economics*, 143.
4. Ibid., 160.

CHAPTER 7:
5. Found at www.dkosopedia.com/wiki/Quotes/Ronald_Reagan.
6. Found at http://thinkexist.com/quotes/James_Watt.

CHAPTER 9:
7. Barry Lopez, *Wolves and Men*, 62.
8. H.A. Guerber, *Myths of Greece and Rome*, 100.
9. Ovid, *Metamorphoses*, trans. Mary Innes, 3:138–252.

CHAPTER 10:
10. Warren Schultz, *A Man's Turf*.

CHAPTER 13:
11. Ovid, *Metamorphoses*, 10:560–680.
12. W.S. Landor, *Hippomenes and Atalanta* in Gayley, *The Classic Myths*, 141.
13. Ibid.

Bibliography

Allen, Thomas J. *The Butterflies of West Virginia and Their Caterpillars.* Pittsburgh, PA: University of Pittsburgh Press, 1997.

Angier, Natalie. *The Beauty of the Beastly.* Boston: Houghton Mifflin, 1995.

Elliott, Doug. *Crawdads, Doodlebugs, and Creasy Greens.* Asheville, NC: Native Ground Music, 1995.

———. *Wild Roots.* Rochester, VT: Healing Arts Press, 1995.

———. *Wildwoods Wisdom.* New York: Paragon House, 1992.

———. *Woodslore.* Union Mills, NC: Possum Productions, 1986.

Gayley, Charles Mills. *The Classic Myths.* Waltham, MA: Blaisdell Publishing Company, 1939.

Guerber, H.A. *Myths of Greece and Rome.* New York: American Book Company, 1893.

Hayes, Jerry. "The Classroom." *American Bee Journal* (February 2005): 107.

Heinrich, Bernd. *Bumblebee Economics.* Cambridge, MA: Harvard University Press, 1979.

BIBLIOGRAPHY

Lopez, Barry. *Wolves and Men.* New York: Charles Scribner's Sons, 1978.

Maeterlinck, Maurice. *The Life of the Bee.* New York: Dodd, Meade & Co., 1913.

Ovid. *Metamorphoses.* Translated by Mary Innes. Baltimore, MD: Penguin Books, 1955.

Schultz, Warren. *A Man's Turf.* New York: Clarkson Potter, 1999.

The works of the author are available at www.dougelliott.com.